T0277405

DARLINGTON

A POTTED HISTORY

COLIN WILKINSON

AMBERLEY

For Adam

First published 2022

Amberley Publishing
The Hill, Stroud
Gloucestershire, GL5 4EP

www.amberley-books.com

Copyright © Colin Wilkinson, 2022

The right of Colin Wilkinson to be identified as the
Author of this work has been asserted in accordance
with the Copyrights, Designs and Patents Act 1988.

ISBN 978 1 3981 0993 3 (print)
ISBN 978 1 3981 0994 0 (ebook)

British Library Cataloguing in Publication Data.
A catalogue record for this book is available from the
British Library.

Typesetting by SJmagic DESIGN SERVICES, India.
Printed in Great Britain.

Contents

Introduction

The potted history of Darlington is simply the story of a group of Quakers who pioneered the railway system – there is nothing more of significance!

Not so. There is a rich history to be revealed from a time in the Dark Ages when a group of Saxon settlers were attracted to a patch of land beside a river and started a farming community. From this modest beginning Darnton, one of the town's many names, became the southern stronghold of the land of the Prince Bishops and grew as a market town serving the folk of the local communities including the villages of Cockerton, Haughton and Blackwell.

Disaster struck in the sixteenth century when fire destroyed much of the town, leaving many homeless and travellers along the Great North Road, who relied on the town's

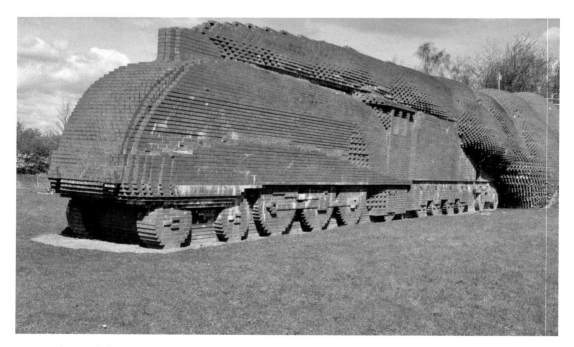

Darlington's long association with the railways is commemorated by this sculpture, completed in 1996 using almost 182,000 bricks.

inns for hospitality, struggling to find lodgings. The town was rebuilt and the linen and woollen textile industries flourished, gaining recognition as the 'most noted place in all the world for manufacture of huckaback' (a stout linen fabric).

Darlington did not stand still. In the nineteenth century a heavy engineering base developed with blast furnaces, rolling mills, forge and railway works. Families were attracted by the availability of work and the population exploded. During the twentieth century these traditional industries ebbed and by the turn of the twenty-first century the economy had diversified again.

These are just glimpses of how the entrepreneurs, reformers, benefactors, heroes, inventors, campaigners and ordinary folk forged the town that is seen today. Alone this is a fascinating story covering centuries of history; however, in addition, there is the story of the town that helped to bring a transport revolution to the world.

The Rise and Fall of Darlington

Flints, pottery and arrowheads from the prehistoric period have all been uncovered around Darlington, but these finds have been limited and sporadic, suggesting there was no settlement in the area. From a later period archaeologists have unearthed evidence of a farm in Faverdale with roundhouses and livestock enclosures. The farmstead dated from the first century but later developments indicated the growing influence of the Roman civilisation. This was seen in a building incorporating a hypocaust heating system and painted walls. It would seem that this was the limit of Roman activity around Darlington, although nearby Piercebridge became an important Roman military base. Here there was a garrison guarding a bridge across the Tees on Dere Street. This was the road from York to Corbridge and the Roman wall. The remains of the bridge on the south side of the Tees give some idea of the size of the building work undertaken. This was the second built during the Roman occupation. The first, a wooden structure, was probably destroyed by flood water, prompting the second, more substantial stone-built bridge. A community grew at Piercebridge, with civilian traders supplying the soldiers billeted at the fort. Nearby, on the southern side of the river was a Roman villa, a grand building around 20 yards long with wings at each end. Like the building uncovered in Faverdale, it was heated by an underfloor hypocaust system.

This distribution warehouse in Faverdale now covers much of the area that an archaeological survey in 2003 revealed was an early settlement, and discovered a house with signs of Roman influence.

The unearthed remains of the Roman bridge across the Tees at Piercebridge.

After the Roman legions left the country in the fifth century, Saxon invaders from northern Germany and southern Denmark sailed across the North Sea and began to settle, creating their villages or 'tuns'. It was in these years that Darlington was born. Reminders of the early Saxon town have been found including a graveyard that was discovered when houses were being built in the Pierremont area. Among the remains were several bronze fibulae (pins that were used to hold garments together), brooches, a necklace, swords, spearheads and a small urn positioned by each skeleton. This may be an indication of the extent of the settlement, as the cemetery would have been placed at the edge of the village. More evidence of these early times has been found around St Cuthbert's Church including Saxon crosses and decorated stonework. There is a suggestion that there was an earlier Anglo-Saxon church on the site of St Cuthbert's Church. Foundations of this early church were reported to have been found when the parish church was being restored in the nineteenth century. There was an indication of an early settlement at Haughton with the discovery of a Saxon cross during restoration work on St Andrew's Church. Perhaps like St Cuthbert's, there could have been an earlier church on the site. While the evidence of these early years of the town has been in the form of unearthed artefacts and remains, the earliest document showing the existence of Darlington dates from 1003 when the Bishop of Durham was granted control of Dearthingtun.

How the name Darlington emerged has brought a number of theories. There is a suggestion that it was based on the name of the local River Dare, which would later become the Skerne. Another proposed that it was named after the settlement's head man. Whatever the origins it has evolved from earlier times when it was referred to

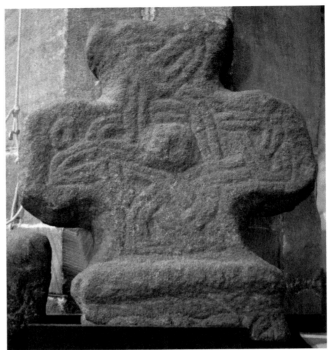

Above left: A square-headed brooch, one of the finds from the Saxon burial ground in the Pierremont area. (AN1909.368 © Ashmolean Museum, University of Oxford)

Above right: Saxon crosses were unearthed during restoration work on St Cuthbert's Church.

The remains of a second Saxon cross found in the grounds of St Cuthbert's Church.

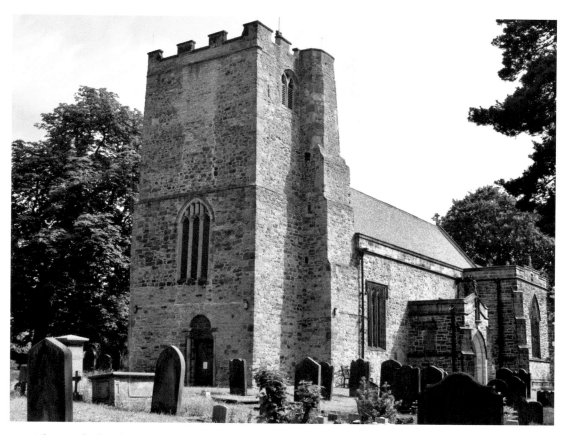

The parish church at Haughton dates from 1125, possibly making it older than St Cuthbert's, which is said to have been built later in the twelfth century.

as Darnton, Darneton, Dearthington and other variations until Darlington was settled on. One theory suggests that the Saxon word 'kukrus', a 'winding stream', was used in naming the settlement of Kukroston, which eventually became Cockerton. Haughton has similar evolution, turning up in ancient records as Halbtune and Halungton; le Skerne was a later addition of French origin, possibly added after the Norman invasion.

The early activities of the Norman invaders did little to aid the progress of the town. William the Conqueror had trouble controlling the north of the country and in 1069 he despatched a force lead by Robert Cumine to stamp his authority. This failed; the army was ambushed and slaughtered at Durham. Later in the year Northumbrian rebels joined forces with Danish invaders who had sailed into the Humber and this combined force attacked York. William acted to completely destroy any further attempts at resistance by sending an army to York. However, the enemy had dispersed – the Danes back to their ships and the Northumbrians into the hills and woodland. The Danes were bribed to return home and forces were sent into the countryside north of York to remove the

rebellious population and destroy their villages, livestock and food stores. This was the Harrying of the North that left those who survived starving.

In the decimated land the Normans then acted to preserve their authority. North of the Tees they turned to the Bishops who had gained considerable influence during Anglo-Saxon times. The Bishops' authority was strengthened with the award of the earldom and the power to raise armies, levy taxes, create markets, issue coinage and administer justice. The land of the Prince-Bishops was born and appointments were made to those supporting the Norman rule.

The Bishops' extensive rights over this land meant that there is no mention of Darlington or any other settlement north of the Tees in the Domesday Book, the survey and valuation of his estates ordered by William in 1085. The revenue from lands above the Tees was in the hands of the Bishops so there was no need to include them in the survey. Today the Domesday Book can be used as a guide to the extent of the towns and villages that existed in the eleventh century but it took until the following century for something similar to be produced above the Tees. In 1183 Bishop du Puiset ordered a review, settlement by settlement, of his lands and the income produced. This was the Boldon Book and a picture of a mainly farming community is seen in Darlington. There were 48 bovates of land in Darlington (a measure of land varying from 8 to 20 acres depending on the nature of the land). As well as paying annual rents of 25p for their farmsteads some tenants were required to provide labour for the Bishop, which included mowing and storing hay from the Bishop's meadow, carting loads of wood, wine, herrings and salt, while others were obliged to operate the Bishop's mill. Cottagers were also mentioned, each with a smaller plot of land at a much reduced rent. Darlington was divided into two areas and the survey mentions the borough where the inhabitants were free of the need to provide service to the Bishop. Here there is mention of cloth dyers at work here, perhaps the start of a textile industry that would become so important to the town.

The nearby villages also supported farmers and smallholders. At Little Haughton (this was the Red Hall area) there was Adam, who held the lease on a farm and looked after the Bishop's houses in Darlington. At Great Haughton duties included working for two days each week for the Bishop between the feast of St Peter's Chains to the feast of St Martin (August until November). Those living in Whessoe needed to work one day a week throughout the year. At Blackwell, there was a note about Adam who paid for the grass at Baydale, while in Cockerton there were 47 bovates leased to farmers.

The Boldon Book noted the separate borough of Darlington. This division was highlighted in another survey carried out in 1380, which listed Darlington with Bondgate. Bondgate was the rural side of the town where houses faced a village green. The layout of the borough was for a different purpose and around the church was the open space of the market square bounded by housing, which at this time reached no further than Skinnergate, Houndgate, Northgate and the River Skerne. Across the river much of the land was given to the Bishop's Park. The two areas in the town centre still reflect the medieval layout, Bondgate still opens out to the space once occupied by the village green and the layout of the centre of the borough of Darlington is still retained in the market square.

Bondgate was the rural section of the town. The ancient layout is still retained as the street widens to accommodate what was once the village green.

The ancient layout of the marketplace is still retained.

While Bondgate only provides a reminder of the village green, there is still a green in Cockerton.

Bishop de Puiset, as well as ordering the Boldon Book to be compiled, turned his attention to the development of Darlington and is credited with ordering the construction of the St Cuthbert's Church seen today. He authorised the holding of a market and a busy market town started to emerge, attracting farmers from around the area to sell their produce and livestock. This was not without benefit for the Bishop who received the tolls collected from those using the market. Darlington was also developing as the centre of the Bishop's activities in the south of Durham. He had a palace built close by the church and raised the standing of the church by appointing four canons or prebends. The canons received income from land and property given to them from the Bishop's holdings. In the early sixteenth century another ecclesiastical building, the Deanery, was erected in the south-east section of the marketplace.

By the sixteenth century John Leland, a poet and writer, described Darlington with 'a bridge of stone, as I remember, of three arches, it is the best market town in the Bishoprick saving Durham ... The Bishop of Durham has pretty Palace in the town.'

The Bishop's palace was the first place in Durham that the church authorities could accommodate their guests arriving from the south. The palace was also used by royal visitors, including in 1502 when Margaret Tudor, the daughter of Henry VII, was on her way to marry James IV of Scotland. There had been intermittent war between England and Scotland for years and this marriage was arranged to help cement a peace agreement.

Right: Bishop de
Puiset depicted
in a window in
St Cuthbert's Church.

Below: A view of the
Bishop's Palace, which
eventually became the
town's poor house.

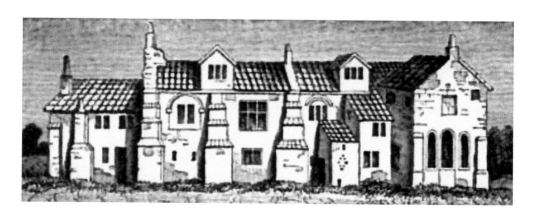

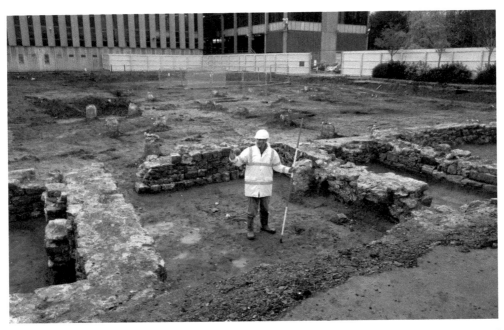

Archaeological excavations were underway in 2013 at the site of the Bishop's Palace. (Courtesy of Centre for Local Studies, Darlington Library)

The site of the Bishop's Palace beside the River Skerne.

However, the accord only lasted until Henry VIII demanded that James V of Scotland follow his lead and break from the Catholic church. James refused and sent an army into England; the Bishop's palace was used as a base by English army commanders, the Scottish army was defeated at the Battle of Solway Moss in 1542 and prisoners were held in the town while discussions for their release took place.

Henry VIII's break with the church of Rome brought radical change to the religious life of the country including the closure of the monasteries and the transfer to the crown of estates that the monks and nuns had amassed. All the turmoil and disruption to the established religious traditions did bring a rebellion in the north involving priests, abbots and local gentry. This was in the latter part of 1536 and became known as the Pilgrimage of Grace. The revolt started in Lincolnshire and spread north with a gathering of supporters reported at Oxenfields just outside the town but no significant involvement of Darlington folk was reported. The incumbent at St Cuthbert's, Cuthbert Marshall, was, however, implicated in the uprising. At the time Marshall was also rector at a coastal village further north and his curate admitted seeking help from Scotland's King James to overcome the religious oppression that had been imposed in England. Suspicion also fell on Cuthbert but he managed to avoid conviction unlike the curate who was executed. Edward VI continued his father's reform of the church and this did impact on Darlington: in 1547 the collegiate church system was removed, the Prepends were dismissed and the income from the land they had been granted was taken by the crown.

The turmoil in religious life continued and Darlington folk became part of the next uprising. Elizabeth I was intent on removing the influence of the Catholic Church, which had been restored by her predecessor, Queen Mary, and re-establishing the country as Protestant. Elizabeth was guarded against plots to restore the Pope's authority and Catholics became regarded as potential traitors. They were persecuted, priests were outlawed and to reinforce the position of the English Church attendance was made obligatory. The Catholic Earls of Westmoreland and Northumberland had fallen foul of Elizabeth, who had acted to reduce their income and authority. When Mary Queen of Scots fled south from Scotland after being implicated in the murder of her husband, the earls saw an opportunity to restore their position. Mary was a Catholic and some argued that she had a better claim to the throne than Elizabeth, who was the daughter of Anne Boleyn. Anne's marriage to Henry VIII could be viewed as illegal, making Elizabeth illegitimate. On the other hand Mary's lineage could not be questioned as she was the granddaughter of Henry VIII's sister, Margaret Tudor. The earls hatched a plan to replace Elizabeth with Mary. Elizabeth's aide in the north, the Earl of Sussex, heard of the plot and naturally informed the queen, who demanded that the two earls present themselves in London. Knowing what their fate would be, they decided they were left with no alternative but to act and on 14 November 1569 entered Durham with an army and held a Catholic mass in the Cathedral. This was the start of the Northern Rebellion. The rebels moved south and were soon recruiting in Darlington where they proclaimed they were acting against the queen's councillors, who were seeking to destroy the ancient nobility and religion. Elizabeth responded by sending an army north. The earls fled to Scotland, leaving their followers to face the consequences. Executions in Darlington were organised by Sir George Bowes, who no doubt was ready to

take revenge after being forced to surrender Barnard Castle when he and his troops were besieged by a band of rebels.

The religious intolerance was brought home to the people of Darlington in 1594 when George Swallowell, who was ordained into the Church of England but converted to Catholicism and from his pulpit preached that he had been encouraged to see the error of his ways when he visited an imprisoned Catholic. This prompted George's arrest and trial for treason. He refused an opportunity to declare his allegiance to the English Church and the judge sentenced him to death. He was taken to Darlington for the brutal hanging to be carried out.

As the troubled sixteenth century moved towards its close disaster struck in 1585 when fire destroyed most of the town. A pamphlet produced at the time described how the flames fed by 'stacks of wood, haystacks and barns' spread the blaze across the town and 'one house was fired by the heat of another'. People were forced to throw their possessions into the street when there was little hope of saving their houses. In all 273 were burned down and it was not an exaggeration for the report to suggest that most of High Row and Skinnergate was destroyed. The town was alight and flames could be seen 'so far as Rosebery Top sixteen miles away'. The report does illustrate the position the town had gained as a 'good harbour for all travellers'. However, the fire razed many of the inns to the ground 'and the spoil thereof is so great that it is not able to receive or entertain the twentieth part of the passengers which heretofore it had received'.

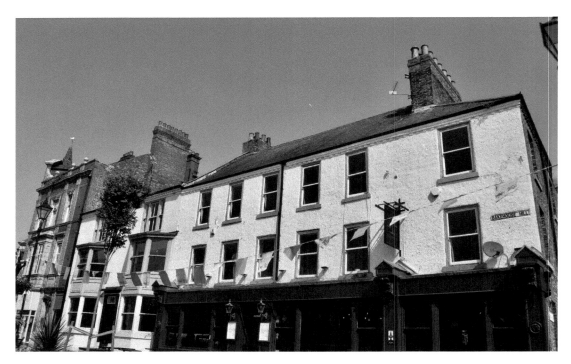

Bakehouse Hill at the edge of the Market Place. George Swallowell's body was said to have been disposed of in a dung hill here.

This section of wall in Church Lane has survived from the sixteenth/early seventeenth century.

A well in Tubwell Row provided water for much of the town. Later a pump was placed over the well. The site is remembered by this replica pump.

Two Centuries of Change

The seventeenth century brought the turmoil of the Civil War, the execution of Charles I, the Commonwealth and then the restoration of the monarchy. The attempt by Charles I to impose reform of the Scottish Church led to war. Scottish troops were victorious at the Battle of Newburn, near Newcastle, in 1640. The English troops retreated south stopping in Darlington and the local villages to destroy the milling stones in the corn mills to make feeding the advancing soldiers difficult. Nevertheless the town was soon occupied and remained in Scottish hands until 1641 when withdrawal of the troops was negotiated. During the following English Civil War there was fighting nearby at Piercebridge (1642) and Yarm (1643) when Parliamentary forces defended the bridges crossing the Tees. These skirmishes were attempts to stop Royalists moving south with supplies, which were being shipped into Newcastle by supporters in Europe.

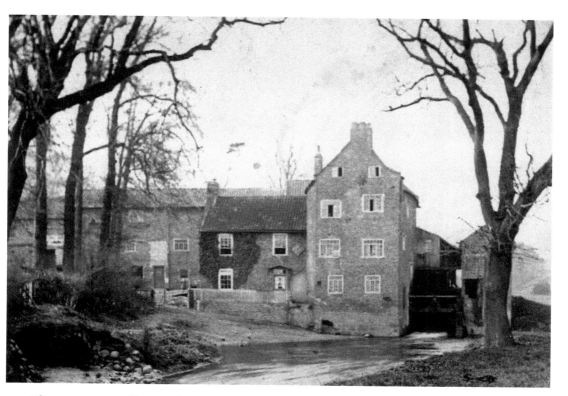

There were corn mills in Darlington, Haughton and Blackwell. This is a mill building at Blackwell before it was demolished in 1938. (Courtesy of Centre for Local Studies, Darlington Library)

This period brought considerable change to the religious life of the country. Church interiors became plainer, fonts and paintings were removed and decorations cleared. William H. D. Longstaffe in his *History and Antiquities of the Parish of Darlington* (published in 1854) recounts the removal of the King's Arms from the walls of St Cuthbert's only for them to be replaced in 1660 when the monarchy was restored. In 1662 the font was reinstated, somebody must have stored it away safely in anticipation that it would be used again. During this time many new religious sects such as the Baptists, Presbyterians, Independents and the Quakers emerged. Darlington soon embraced the Quaker movement and by 1678 the Friends, as they are often referred, had a meeting room in Skinnergate. This was on the site of the existing building, which dates from around 1840. Cockerton also attracted Quakers, but their meetings were held in private houses. The Quaker families of Darlington are closely linked with the growth of the town. Peases and Backhouses are perhaps the most remembered, both families originally working in the textile industries before expanding their business interests.

The Friends Meeting House in Skinnergate dating from 1840.

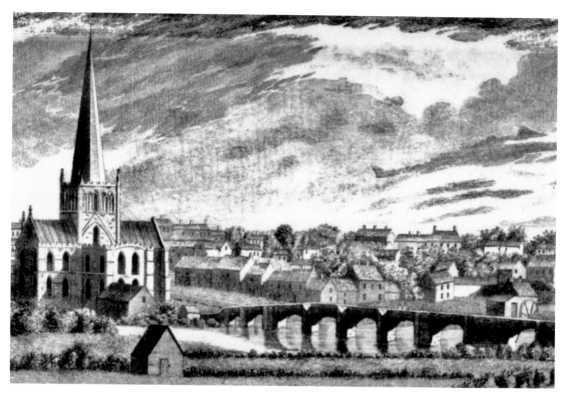

The town *c.* 1760 with the stone bridge across the wide section of the river.

Daniel Defoe recognised the town's capability in textiles when he visited in 1727 but he found little to admire and wrote 'it has nothing remarkable but dirt, a high stone bridge over little water, the town is eminent in the bleaching of linen'. At that time the bridge crossed the river at the point where a diversion of part of the Skerne supplying water to the mill race rejoined the main river to form a wide flow. He was not the first to complain about the condition of the town: a century earlier James I had christened it 'Darnton in the dirt'. The problem came from two sources: the townsfolk who kept animals but would only occasionally clear the dunghills piled up beside their houses. The court could be used to punish offenders and in 1763 fines of 1s 6d for 'laying down a dung hill' were imposed. The animals brought to the market also created mess.

The market was held every Monday, details given in 1748 noting that an additional market was held on the day before Christmas. Tolls were charged for those bringing produce to the market but some days there were exemptions; on the first Monday in March no charge was made for cattle. Cattle were also exempt on Easter Monday but a charge was made for horses, pigs and sheep. Some days had a particular focus, November had days for sale of pigs and horses. Hiring of servants also took place in the market. The Monday before 'old May Day' was a hiring day as was the Monday after 'old Martinmas Day'.

The town was growing. By 1767 a survey reported there were 885 households and 3,280 people living in Darlington. The increasing population brought the need for more homes, which brought the emergence of the yards around the town centre, some of which are still extant between High Row and Skinnergate. Initially the houses and shops in these streets had gardens and stabling behind them. In 1738 a house near the marketplace was advertised for sale with 'good garden at back'. Another on High Row was offered with stabling, brewhouse and hay loft. Gradually the opportunity to profit by giving up these gardens and outhouses to make way for houses led to the formation of the yards.

By the mid-eighteenth century the town was busy providing the tradesmen and services that could be expected in a busy market town including shoemakers, druggist, tailor, physician, whitesmith, blacksmiths, gunsmiths, schoolmasters, barbers, breeches makers and grocers. There were inns looking after the travellers along the Great North Road, as well as those attending the market.

Clark's Yard between High Row and Skinnergate, one of the many yards developed in the eighteenth century.

In Clark's Yard this rainwater downpipe suggests the age of some of the properties in the yard.

The town has many listed buildings ranging from St Cuthbert's Church to garden walls and includes examples from the villages. Among them are these two houses in Cockerton dating from the late eighteenth century.

Not all prospered and it was the responsibility of the parish to provide relief for the poverty-stricken and to appoint an Overseer of the Poor. The Overseer was responsible for providing work for the unemployed, finding apprenticeships for destitute children and administering, with the churchwarden, the workhouse and collection of the Poor Rate. A listing of payments for this local rate in 1787 shows varying amounts collected from around the town, ranging from 3d from a house in Bondgate to 6s 8d for the Black Lion in Church Row.

The Bishop's palace had been repaired and renovated over the centuries but became little used by the Bishops and by 1702 had been adapted to be the workhouse. In 1757 John Stubbs was the master of the workhouse and the meals he provided his inmates were repetitive and made full use of the local farm produce:

Sunday
 Breakfast 8 oz bread, one pint of milk porridge
 Dinner 5 oz bread, broth, 8 oz of flesh with roots or pease
 Supper 7 oz bread and broth
Monday
 Breakfast 8 oz bread and broth
 Dinner 8 oz cake and one pint of milk
 Supper 8 oz bread and one pint of milk
Tuesday
 Breakfast 8 oz bread, one pint of milk porridge
 Dinner One pint of milk frumenty (a thick porridge)
 Supper 8 oz bread and one pint of milk
Wednesday
 Breakfast 8 oz bread and one pint of milk porridge
 Dinner Dumplings and sauce
 Supper 8 oz bread and one pint of milk
Thursday
 Breakfast 8 oz bread and one pint of milk porridge
 Dinner 7 oz bread, broth, 8 oz of flesh with roots or pease
 Supper 8 oz bread and broth
Friday
 Breakfast 8 oz bread and one pint of milk
 Dinner 8 oz cake and one pint of milk
 Supper 8 oz bread and one pint of milk porridge
Saturday
 Breakfast 8 oz bread and one pint of milk
 Dinner 10 oz dumplings and sauce
 Supper 8 oz bread and one pint of milk

It was felt that too much bread was given and the following year it was reduced to 'as much as they could eat at meals'.

Darlington's overseers of the poor were provided with instruction; they were not to 'relieve any person out of the workhouse except through sickness or largeness of family

and judged to receive relief occasionally or in the case of infectious diseases'. Providing aid outside of the workhouse was not encouraged as the harsh regime inside made finding work an attractive alternative. Overseers were also required to 'take care, from time to time, to place and put out apprentices, all poor children of the workhouse at the age of ten years'. The age restriction seems to have been ignored in the case of Thomas Dixon, at the age of seven, who was apprenticed as a flax spinner for eight years to John Kendrew at Haughton. Jane Pearson fared a little better as she was eleven when she was apprenticed to John Kendrew.

Help for the poor did not rest solely on the parish. Charitable donations helped, and often wills would include some provision. Robert Noble, an apothecary, left funds for £1 per year to be distributed to the poor. Elizabeth Walker left £50 to be invested in government securities and the interest received was to be distributed on Christmas Day to twelve poor widows.

Darlington was on the major route north from London and its position as a resting point for travellers seems to have been recognised by Bishop Puiset when he built his palace in the town to provide accommodation for his visitors. For those not privileged enough to be invited to the Palace, the town had inns ready to welcome travellers. One of Darlington's early inns was the Bull, owned by the Bulmer family who are still remember in Bull Wynd. There were many more, many of which have disappeared including the Talbot that straddled High Row and Post House Wynd and the Sun Inn on the corner of Bondgate and Northgate. In the Horsemarket was the Dolphin. The town's leisure centre revived the name. The King's Head dating from the eighteenth century is one name that survives. The significance of the town on the road network was

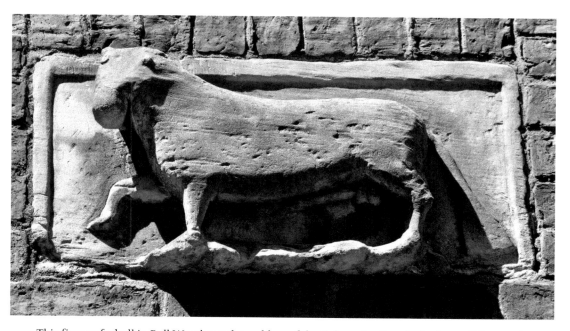

This figure of a bull in Bull Wynd was the emblem of the Bulmer family, who had one of the town's early inns.

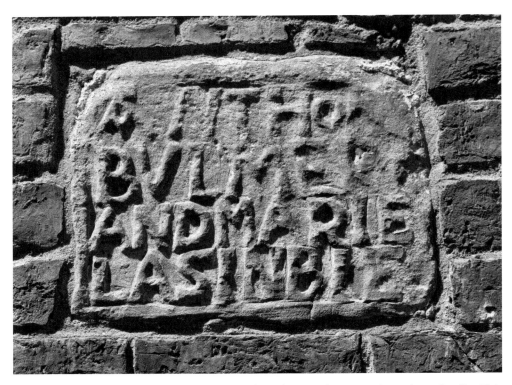

Also in Bull Wynd alongside the bull is another plaque relating to the Bulmer family. This remembers Anthon Bulmer and Marie Lasinbie's marriage in the seventeenth century.

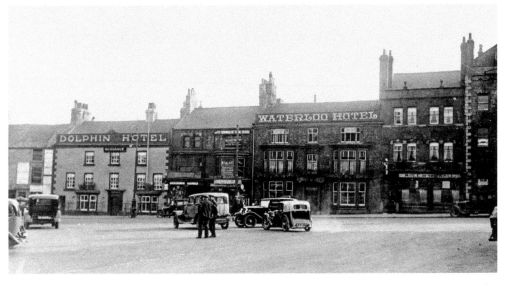

The Dolphin Hotel once had stabling available and was still open into the twentieth century. The town's Dolphin Centre recalls its predecessor. (Courtesy of Beamish Collection)

recognised by Sir Walter Scott in his book *Rob Roy*. This was set in the early eighteenth century and brings a traveller to Darlington on his way north who, as was the usual practice in those days, does not travel on Sunday and remained at the inn to 'attend divine service and his horse have the benefit of the day of rest'.

Scott also wrote that journeys 'of length were by brief stages'. This is not surprising as travelling could be torturous and dangerous. In 1775 there was concern about lawlessness and a group met in Darlington to consider 'proper steps to be taken for the preservation of property, from the too frequent depredations of highway men, house breakers and other offenders'. Attacks by highwaymen were reported and when caught the penalty could be severe. In 1748 Edward Quail was sentenced to death for robbery on the road between Darlington and Durham. It seems stagecoach operators were concerned about the threat and in 1770 the London post coach warned that it 'would not carry money, jewels, watches or plate' and 'would not be answerable for any such article'.

The roads were often in poor condition and travel could be slow and uncomfortable. In 1764 a coach was running from Newcastle to York. This took three days with an overnight stop in Darlington after the first day. Perhaps the express coach that was running from Newcastle to London in 1772, scheduled to take three days, would only stop in Darlington for a short time and was one of the 'numerous stage coaches which every day and night rattled through the town, some of them to the sound of the bugle, and changed horses at the King's Head'. The stop at the King's Head lasted only minutes as new horses were harnessed.

Maintenance of the roads was haphazard as individual parishes were responsible for the care of their roads. Each was expected to appoint a Surveyor of Highways to look after the maintenance and organise the people of the parish, who were required to give up some of their time to work on the roads. Naturally there was little enthusiasm for this and on busy routes a lack of labour and limited funding for materials left some roads no more than muddy tracks full of pot holes. One solution to this problem was the forming of turnpike trusts, which transferred the cost of maintaining the roads from local inhabitants to those using them. In 1745 Darlington saw its first turnpike. This was the road from Boroughbridge passing through Northallerton to Croft into Darlington and on to Aycliffe and Durham. This was followed in 1747 by the road from Stockton via Darlington to Barnard Castle. Despite the potential the turnpikes brought for improvement the condition of the roads could still be far from perfect and in 1770 Arthur Young noted in his *Six Months Tour through the North of England* that from Croft Bridge 'to Darlington is the great north road, and execrably broke into holes, like an old pavement, sufficient to dislocate one's bones'.

Next came the 'coal roads'. These ran from the mines in south Durham into the towns. In 1751 the road from West Auckland to Darlington was turnpiked together with a connection to the road to Stockton and a spur to Piercebridge that provided a route into North Yorkshire. Two more roads into Darlington followed: in 1795 the road from Cockerton to Staindrop and in 1832 from Blackwell to Stapleton.

The turnpike trust was responsible for maintaining their roads and to cover the cost those using the roads had to pay. Wagons attracted the highest charges and the toll was often dependant on the width of wheels. Wagons with narrow wheels were responsible

for more damage and attracted greater tolls than those that spread the load with wide wheels. For example on the Durham–Boroughbridge road the charge in 1792 for a wagon pulled by four horses with wheels 9 inches wide was 2s, while those with wheels less than 6 inches wide had to pay 4s. To collect the fees toll gates were set up along the roads at the joining points. Darlington was bounded by these gates and beside them houses were erected for the gate keeper, including at Harrowgate Hill on the road to Durham, Burtree Gate on the coal road, at Baydale on the road to Barnard Castle, Haughton on the Stockton road and Croft on the road south.

WHORLTON and STAINDROP TURNPIKE ROAD TOLL's to be taken at this GATE.

	d.
For every Horse, or other beast of draught drawing any, Coach, Chaise, Gig, Chair, Van or other such Carriage, when drawn by Six Horses	4
When drawn by Four or Three Do	4
When drawn by Three or Two Do	4
For every Horse, or other beast drawing any Wagon, Wain, Cart, or other Carriage, where the wheels are of a Gauge of Six Inches	3½
Where less Gauge than Six Inches and more than four and a Half Inches	4
Where less Gauge than four and a Half Do (Merchandise)	5
Where less Do than Do and a Half Do (COALS)	3
For every Horse or other Beast laden or unladen	1½
For every drove of Cattle, per score (And so on in proportion for any greater or less number)	5
For every drove of Calves, Pigs, or Sheep per score (And so on in proportion for any greater or less number)	2
FOOT PASSENGERS.	1

For any horse drawing any cart etc. passing through this gate having passed through Newsham Park Gate half above tolls

By Order of the Trustees
John Lamb, Clerk

Take a ticket for Newsham Park Gate

The charges for using the turnpiked road are reproduced at the toll keepers cottage near the Whorlton Suspension Bridge.

There was another innovation in transport during these years that did not, despite attempts, arrive in Darlington. In the north-west the Duke of Bridgewater built a canal to carry coal from his mines to feed the ever-growing demand from industry based in Manchester. No longer were wagons or packhorses needed to negotiate the poor roads and transport costs were drastically reduced, with a consequent fall in the price of coal in Manchester. The merchants and mine owners around Darlington saw the benefits that could flow from a canal from the coal fields. In 1767 a meeting was held in Darlington to promote a canal and James Brindley, who was becoming renowned as canal builder, was asked to survey a route, although he passed much of the work to his son-in-law James Whitworth. A report was prepared that proposed a route from Winston via the village of Cockerton to Darlington and then to Stockton, with branches connecting to the roads that ran into North Yorkshire at Piercebridge, Croft and Yarm. This was a grand plan but it came to nothing. The amount of coal that would be sold in the main towns of the area, Darlington, Stockton and Yarm, was deemed not to be large enough to provide the required income to give a return on the estimated construction cost of £64,000. Elsewhere in the country a canal network was under construction, improving transport links and aiding industrial development, but Darlington would have to wait for the pioneering development of the railway to open up its economy.

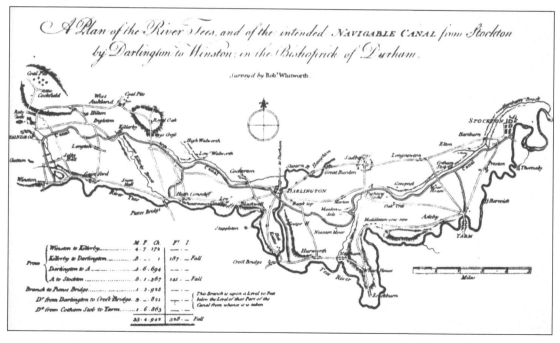

Plan of the canal from Winston to Darlington and on to Stockton proposed in the eighteenth century.

Railways, Banking and Textiles

Canal mania did not flow as far north as Darlington. However, as the eighteenth century progressed the town's industries were attracting attention. A traveller who visited in the 1750s commented on the industry seen 'in its river, the Skerne, grow the green round reed ... which are used to make mats, chair bottoms and bed bases. There is also a stamp mill for softening the flax that comes from Holland and is used in large quantities for linen manufacture. At the weaving mills there are large numbers of looms, producing cloth for women's petticoats, for sheets and for tablecloths ... and men's waistcoats'. There were also tanners at work in the town but textiles were becoming the main focus of the town's industrial activity. Linen manufacture provided work for flax dressers and weavers, and the manufacture of woollen cloth, employing wool combers, spinners and weavers, was also developing.

By the end of the century the importance of the textile industry to the town allowed the *Universal British Directory of Trade, Commerce and Manufacture* to explain in 1791 that the principle manufacture of the town was 'linen and woollen, of which the former exceeds that of any town in England'.

It was the textile trade that produced the Quaker dynasties that had such a significant influence on the town's prosperity. Edward Pease (1711–85) arrived in the mid-eighteenth century to work in the wool combing business of his uncle, Thomas Couldwell. Edward eventually took over the business and expanded it to incorporate all the processes in cloth production including spinning, weaving and dying. Edward was followed by his son Joseph (1737–1808), who continued to grow the operation based in mills in Priestgate and the Leadyard. Part of the mills were little more than warehouses, where material was handed out to those working with spinning wheels or looms set up in their homes; after completing the batch of work it would be taken to the mills, payment received and the next consignment collected.

However, things were changing and much of the process of textile manufacture became mechanised forcing work to move into mills where power for machinery could be provided. In 1733 John Kay's flying shuttle improved the weaving process. This allowed weavers to increase their output, leaving those spinning the fibres into thread with their simple spinning wheels unable to keep up with demand. Three inventions began to provide mechanised solutions. First came the spinning jenny, then Arkwright's water frame, which was patented in 1769, then, around 1778, Samuel Crompton produced the spinning mule, which had the advantage of producing a finer thread. There is a reference to the mechanisation of the Pease mill in 1796 when it was reported that 'Pease's was the third mill in England where worsted yarn was spun by machinery'.

The inventions noted so far were aimed at the wool and cotton industry. However, in Darlington there were linen manufacturers including the Backhouses, another Quaker

family. They supported the efforts of two Darlington men who set out to produce a spinning machine for the fibres extracted from the flax plant, the raw material used to produce linen. John Kendrew, who had been grinding optical glass in the town's Low Mill, worked with Thomas Porthouse, a watchmaker, to produce a flax spinning machine. They patented the machine in 1787 and had some success in licensing its use. Marshalls of Leeds used the machine but eventually stopped paying the licence fees, the partners took legal action but Marshalls were able to successfully argue that the improvements and changes they had made to the equipment rendered it radically different to the Kendrew and Porthouse machine. Having failed in making their fortune through invention, the two went on to operate their own linen mills. Porthouse in Coatham Munderville and Kendrew in Haughton where, as noted above, he took poor children into apprenticeships.

The linen trade in the town declined during the nineteenth century. Leeds emerged as the manufacturing centre, leaving the Backhouses to concentrate on the development of their banking enterprise. This had initially been offered by Jonathan Backhouse as part of his linen business, with customers and suppliers who, rather than holding surplus cash, would leave funds with the Backhouse bank. The reputation of Quakers for their honesty and caution in business undertakings gave confidence to those who left funds deposited with the bank. This bank was substantial enough to issue its own notes by the late eighteenth century. Expansion continued and other local banks were taken over. This included Mowbray, Hollingsworth & Co., who's premises were in High Row and in 1866 were replaced by a grand new building for the Backhouse Bank, which operated from there until it became part of the Barclays group. Banks being operated as a facility provided by traders was not unusual and the Pease business also started to offer a banking service as part of the textile business.

By this time the Pease business was being run by Edward (1767–1858), the grandson of the Edward who arrived in Darlington in the mid-eighteenth century. This Edward played a vital role in bringing the Stockton & Darlington Railway (S&DR) to life. The railway remains a significant part of the town's heritage and is celebrated as a pioneering event in the developing railway system. However, it was not a miraculous breakthrough that introduced a previously unseen, wonderous new transport system. It brought together much that had been developed over centuries, speeded up by the engineering advancements of the Industrial Revolution.

Further north around Newcastle and Sunderland, coal from the mines had to be taken to the docks on the Tyne and Wear ready for export, mainly to London. A system of primitive railways was built to transport the coal. In the mid-eighteenth century a visitor noted that 'transportation from the mines to staithes is carried out by the so-called wagons. The wagons run on four solid wheels, either turned from a single piece of oak or cast in iron ... The roads are provided with wooden rails on both sides to ease the movement of the wheels.' A considerable network of wagonways was built. One route passed over the Causey Arch, which was built around 1725 to cross a river valley and is preserved as the oldest surviving railway bridge.

Railways were not confined to the north-east. They were being introduced throughout the country, sometimes to connect mines and quarries to the canal system. Wooden

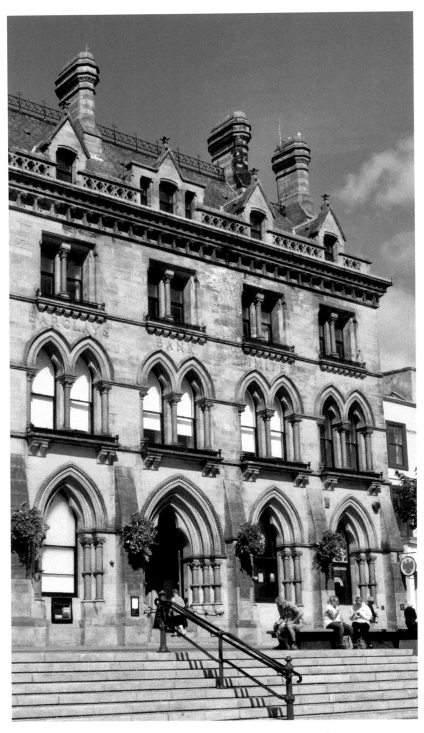

Barclays Bank in High Row, built in 1866 for the Backhouse Bank.

rails were common but iron rails were the next development, providing a more durable track. While freight was the driving force behind the early railways, passenger services were available. For example in the early years of the nineteenth century the Swansea & Mumbles Railway was operating a coach pulled by horses. Some were open to the public. The Surrey Iron Railway opened in 1805 and advertised the charges for those wanting to use their wagons on the line.

While horse-drawn wagons and coaches were used on the early tracks, the power of steam was being harnessed. Matthew Boulton and James Watt improved the performance of engines and Richard Trevithick built the Puffing Billy, a road vehicle powered by a steam engine. The condition of many roads has been mentioned and the use of steam vehicles on the road was not practical, so railways proved to be a better option. In 1810 the Middleton Railway was operating a locomotive along its 4.5-mile track taking coal from a mine into the centre of Leeds. Reports of the opening told of thousands lining the route waiting to witness the mighty 'steam engine of four horses power ... capable of moving, when lightly loaded, at 10 mph'. Further north colliery owners were experimenting with steam power. They began to realise that it was becoming a practical form of transport and provided savings over wagons pulled by horses. The owner of Wylam Colliery had locomotives travelling along rails by 1813. A year later George Stephenson had locomotives running at the colliery in Killingworth. In 1822 the Hetton Colliery Railway was opened, linking the mine to the docks at Sunderland, using stationary steam engines to haul wagons up inclines then locomotives along the level stretches of the 8-mile line.

So what was so special about the S&DR? Railways were not new nor were steam locomotives or public railways or railways taking passengers. What the S&DR did was to bring together the separate elements seen elsewhere; it was open to the public, could be operated by steam engines, its length of 26 miles was ground-breaking, and it also had passenger services running, at first in horse-drawn carriages.

The railway was opened in 1825, although it had been suggested as far back as 1810 at a celebratory dinner to mark the completion of a cut in the River Tees near Stockton. This diversion of the river removed a meandering stretch near Portrack and reduced the distance from the port at Stockton to the open sea by around 2 miles. During the dinner the construction of a railway or canal from the collieries in the South Durham coalfield was championed and a committee was formed to progress the scheme. Progress was slow and it took until 1813 for a survey to be completed. This recommended a canal that would follow the route of the eighteenth-century proposal. The total cost with branches to Piercebridge, Croft and Yarm was estimated at £206,000, and there was little hope of raising so much money in the difficult economic climate of the time. However, the scheme was not completely abandoned, as a proposal for a combination of a canal between Darlington and Stockton and a railway for the remainder of the route to Winston was considered.

Meanwhile in Stockton, Christopher Tennant was busy producing plans for a canal to start in the coalfield and take a northerly route to Stockton, avoiding Yarm and Darlington. This prompted action in these towns and the 'Darlington Committee' started to act. Richard Miles, a timber merchant from Yarm, voiced opposition to the canal explaining that by taking this northern route vital revenue from the two towns would

be lost, and there would be little chance of making a return on the investment of over £200,000 needed to pay for the construction. Another Yarm resident, Richard Cairns, made a significant contribution to the scheme by inviting his brother-in-law, who had been involved in building railways in Wales, to visit and survey a railway. This was George Overton, who produced a plan for a railway from the coalfield via Darlington to Stockton passing close to Yarm. In comparison with the cost of canals the railway, estimated to cost £124,000, looked a better investment.

In the meantime the scheme proposed by Christopher Tennant was in trouble. Funding could not be raised but the Darlington scheme was able to find backers. Money for the railway was raised, the Backhouse and Pease families investing considerable sums and using the Quaker network to draw funding including a substantial investment from the Gurneys of Norwich. Obtaining parliamentary approval for the line presented difficulties, with objections from landowners, in particular Lord Darlington and from mine owners around Newcastle who did not want competition to their valuable trade to London. As part of Lord Darlington's campaign against the construction of a railway across his land he tried to weaken the support for the railway by hatching a plan to make the Backhouse bank fail. In 1819 his tenants were asked to pay their rent in Backhouse bank notes. He hoarded these until he felt that he had enough to present them and demand payment in gold, expecting that it could not be raised. Backhouse survived as he was able to call on deposits from London and the story ends with the coach carrying gold hurrying on its way from the capital but as it sped through Croft it lost a wheel and in order to waste no time the gold was repositioned so the coach could finish the journey on three wheels. It took three attempts before MPs voted to pass the Act authorising the line, eventually gaining royal assent on 19 April 1821.

'Balancing the Cash', the coach loaded with gold dashing towards Darlington to save the Backhouse Bank.

George Stephenson's pioneering work at Killingworth was becoming recognised and it was not surprising that he caught the attention of those developing the S&DR. Edward Pease encouraged the appointment of Stephenson as the engineer for the railway after he visited the mines at Killingworth and watched the steam locomotives at work. He persuaded his colleagues on the committee controlling the development of the railway to use locomotives and with some foresight commented 'don't be surprised if I should tell thee there seems to us after careful examination no difficulty in laying rail road from London to Edinburgh'. On 28 April 1821 George Stephenson wrote to Edward Pease saying he was 'glad the Bill has Passed for the Darlington Railway' and 'I shall be happy if I can be of service in carrying into execution of your plans ... I would be willing to undertake to survey and mark out the best line of way within the limits of the Act of Parliament'.

Stephenson's survey reduced the length of the railway. Nevertheless the completed line was a complicated affair, with stationary engines needed to haul the wagons up hills that were too steep for locomotives at Etherley and Brusselton. On reaching Shildon locomotives could be used, the first being Stephenson's *Locomotion*. While the line was built to carry minerals, soon a passenger service ran between Darlington and Stockton initially using stagecoaches but modified to run on the rails.

At the time the Stockton & Darlington Railway was being developed Edward Pease was living in Northgate and the house still has a reminder of his work in progressing the railway.

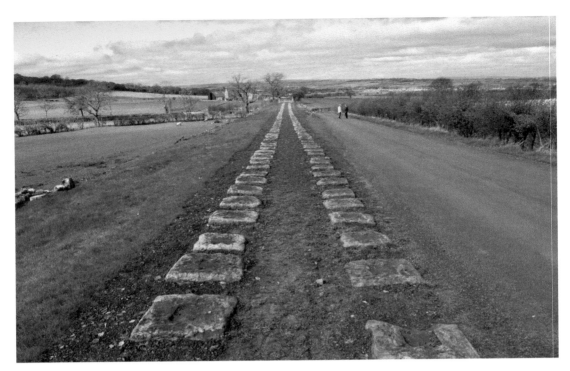

Brusselton Incline near Shildon. The Stockton & Darlington Railway used a stationary engine to haul wagons up this incline.

The engine house at the top of Brusselton Incline.

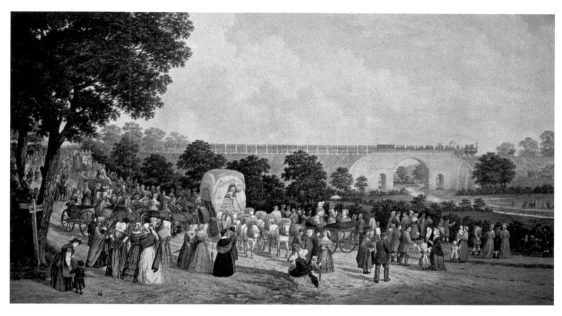

The opening of the Stockton & Darlington Railway and *Locomotion* crossing the River Skerne in Darlington.

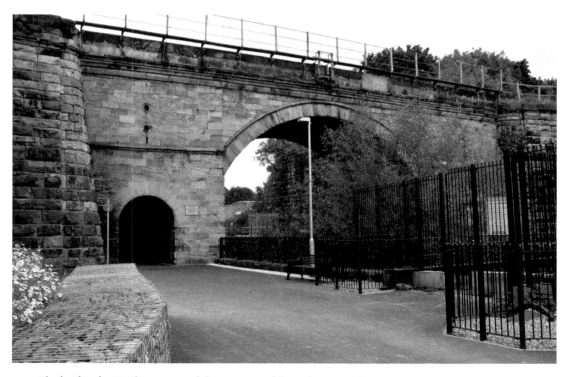

The bridge depicted in scenes of the opening of the railway is still in use.

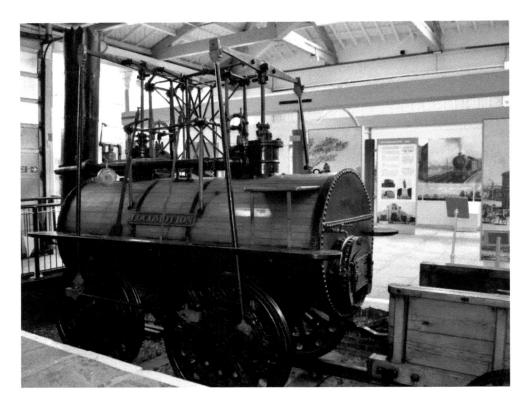

Above: *Locomotion*, the engine that hauled the first wagons along the Stockton & Darlington Railway.

Left: An advertisement for the early passenger service on the Stockton & Darlington Railway. (Courtesy of Beamish Collection)

The railway added to the business interests of the Pease family and by the time the railway was opened Edward's sons, Joseph (1799–1872) and Henry (1807–81), emerged as the next generation to build the business empire. Joseph bought interests in a coal mine in West Auckland, a sound move as the railway was soon transporting enough coal to allow exports from the Tees to begin. The coal was loaded onto ships at Stockton but sailing from Stockton to the open sea, despite the cutting, took time and was dependant on tides. A port further down river was needed. The S&DR was extended to the hamlet of Middlesbrough, which was to be transformed into a thriving town by the owners of the Middlesbrough Estate including Edward and Joseph Pease.

The railways built so far had been in an east–west direction but attention turned to north–south travel and it was the line from York to Newcastle that brought George Hudson to Darlington. Hudson built a considerable railway business by forming railway companies and by acquisition until he secured control of around a quarter of the railway lines in the country, becoming known as the 'Railway King'. His York & North Midland Railway was part of a route from York to London and the next stage was to move north from York. Hudson invested in the Great North of England Railway Co. (GNER), promoted by Joseph Pease, which was planned to run from York to Newcastle. The section between York and Darlington was opened in 1841. There was a celebratory dinner at the King's Head Hotel at which George Hudson was present. However, the next stage, on to Newcastle, which was expected to cut the journey time from London to Newcastle to a day, was in doubt because the GNER had used all its funds building the southerly section. Hudson stepped in, formed a new railway, the Newcastle & Darlington Junction Railway, and took over the project from the GNER, cutting out Joseph Pease and the S&DR, which would have benefited from part of the original route using its lines. Perhaps Joseph would have gained some satisfaction when Hudson's corrupt management of his railway businesses was exposed. He was found to have paid railway company cheques into his personal account but recording them as payments to contractors or to landowners for purchase of land for new lines. He also manipulated the accounts of his companies to publish favourable results. The Railway King was dethroned.

Nevertheless Darlington was becoming well served with railways and stations. Bank Top station was opened in 1841, which brought development of the area and while his reputation was still intact George Hudson laid the foundation stone of St John's Church in 1847. The Bank Top station used today dates from 1887. The S&DR had not built any stations as part of the original line, not recognising any need to provide facilities for passengers. In Darlington a depot/warehouse on the east side of High Northgate was used by passengers until North Road station was opened in 1842. As well as the station, there are other reminders of the S&DR in the Hopetown area; the line branched to lime drops where wagons would bring lime, used in building trade, to the top floor of the building ready to be dropped to the lower level where carts waited to be loaded. Nearby the station is the coach building works opened by the S&DR in 1853, which still retains its heritage with the railways and is the home of locomotive preservation and building groups. The S&DR's line entered Darlington to the north of the main town. However, there was a branch to a coal depot a little closer to the town centre and to serve those working and trading at the depot, the Railway Tavern was built.

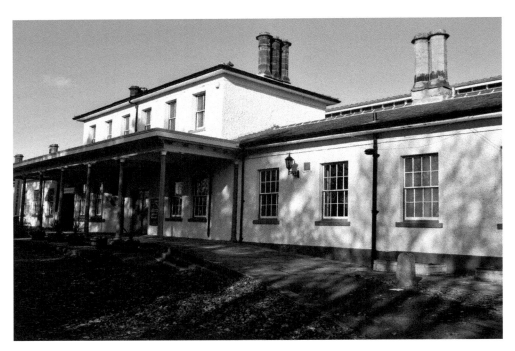

North Road station was opened in 1842.

The railway brought lime into the town and this building near the North Road station housed the lime drops used to release lime from wagons into carts waiting in the lower floor.

More lines followed. Richmond was reached in 1846 and in 1856 the railway to Barnard Castle opened after much opposition from Lord Darlington, who would not accept 'this very objectionable line ... [through what] may be called the Garden of Eden' and a route avoiding his land had to be found. From Barnard Castle the Pennines were crossed and later the track was extended to Middleton in Teesdale.

The importance of the railway to the town has been remembered on every fiftieth anniversary of the completion of the S&DR. In 1875 the streets were lined with flags and banners as part of the celebrations, the North Road Locomotive works were turned into an exhibition site and the statue of Joseph Pease that still watches over the town centre was unveiled.

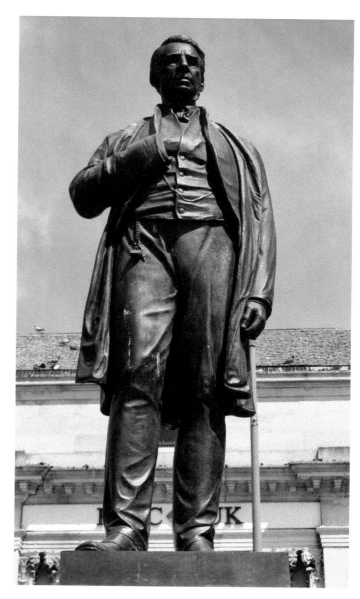

The statue of Joseph Pease was unveiled in 1875 as part of the celebrations of the jubilee of the Stockton & Darlington Railway.

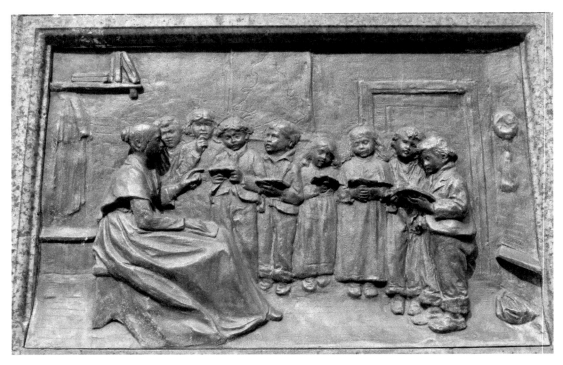

There are four plaques around the statue of Joseph Pease. This one illustrates his role in supporting education and the provision of schools.

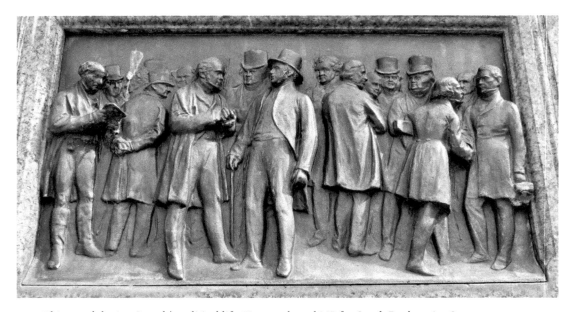

This panel depicts Joseph's political life. He was elected MP for South Durham in 1832.

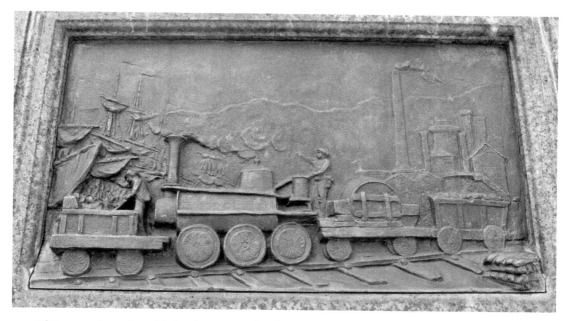

This scene shows Joseph's involvement in developing the railways, the iron industry and the port at Middlesbrough.

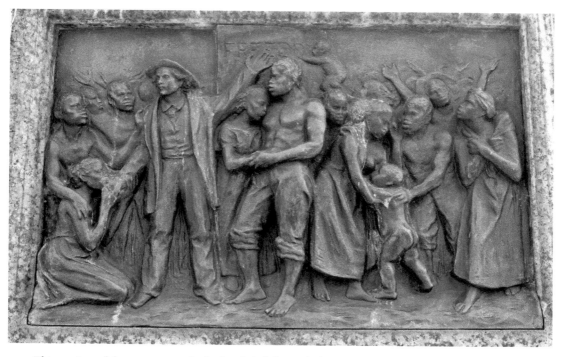

This section of the statue records the family's fight to abolish slavery.

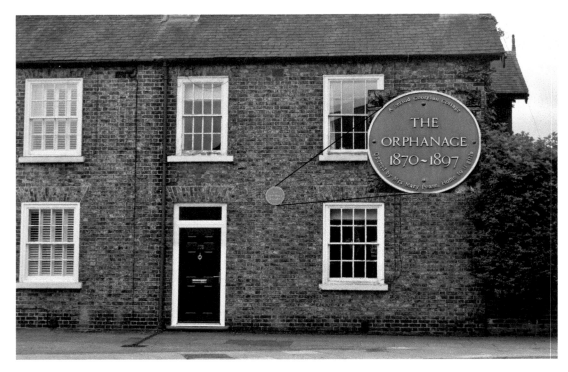

The benevolence of the Pease family is seen here with support for an orphanage in Cockerton. It was opened by Mary Pease, the wife of Henry Pease. By 1891 Jane Kerr was the matron and Florence Green the teacher. They were looking after girls aged five to fourteen.

4

A Growing Town

At the time the S&DR opened the railway ran to the north of the town. Even the branch heading south did not reach into the central area. Darlington was still a small, compact town. A map from 1826 portrays the marketplace surrounded on three sides by housing. The town is starting to stretch out along Northgate but bounded on the other sides by Skinnergate and Houndgate. Within the church grounds, by the river, is the grammar school and nearby the poor house. Across the wide river there is some development including a tannery and a textile mill. On the fringes are grand houses enclosed by extensive gardens and woodland. This includes Pierremont, which was built by the Botcherleys, a family making their money from trading in iron and timber. The town

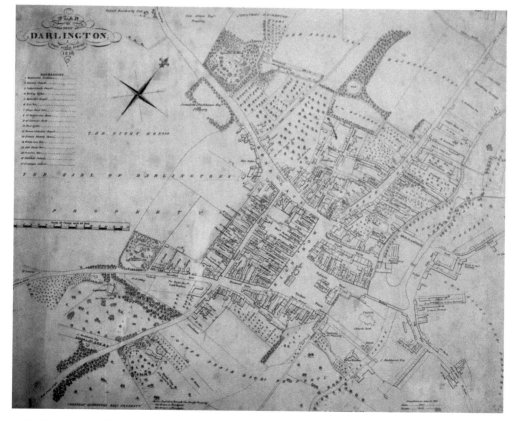

A Darlington map from 1826, a small town surrounded by countryside, much of which would be overtaken by the town. (Courtesy of Centre for Local Studies, Darlington Library)

is surrounded by land owned by the Pease family, the Backhouses, Lord Darlington and George Allan, which will eventually be given over to development. The limited size of the town was highlighted again in 1838 when Holy Trinity Church was completed in Woodlands Road. At the time the church was in the countryside, away from housing, and was approached by field paths.

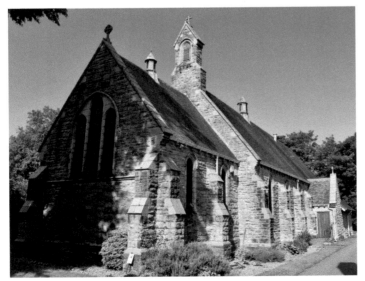

Above: Blackwell Grange, once a home of the Allan family. They also had extensive landholdings including around Albert Hill, which was sold to allow the industrial development in the area.

Left: The people of Cockerton could use Holy Trinity Church when it was opened in 1838. However, it took until 1901 for St Mary's Church to be opened in the village.

As the nineteenth century unfolded there was extraordinary growth that would take the town away from the ancient boundaries. The population in 1801 was around 4,700, growing over the next fifty years to reach 11,500. Then in the twenty years that followed there was an increase of over 140 per cent, bringing the number of people to nearly 28,000 by 1871. During these years the industrial outlook for the town changed. Some manufacturing declined, others endured but it was the new industries that transformed the town, bringing the population explosion that forced builders onto greenfield sites to take housing towards the villages.

The Pease family diversified their business activities into railways, collieries and new towns but did not forget the textile business from which the family fortune had been created. In 1837 the Railway Mill was bought. This was in the northern part of the town and had around 400 looms working. By the early 1840s the demand for textiles was suffering from a downturn but the importance of the mills, which had become major employers, to the wellbeing of the townsfolk was not forgotten. Edward Pease recorded in his diary in 1842 how he 'entered with my three dear sons onto serious conversation as regard the mill concerns. The distress it would cause the poor and the loss of £30,000 to £40,000 would render it prudent to try for another year'. This proved to be a wise reaction and the mills continued in business. However, some of the established trades including linen and the relatively small number of carpet weaving enterprises declined.

The railways brought some new opportunities and a thread can be followed from a shop in Tubwell Row to the story of three engineering firms that are part of the town's industrial heritage. The Tubwell Row shop, which had a foundry behind, was run by William and Alfred Kitching, who supplied the S&DR with nails worth 15 guineas. From this modest beginning the story leads to the North Road Locomotive works, Whessoe Engineering and the Rise Carr Rolling Mills.

Seeing the potential, the railway offered for supplying more than nails the Kitchings moved to larger premises in Hopetown and started to build coaches and locomotives. This included, in 1845, the Derwent, which has been preserved and on display in the town's rail museum. Alfred Kitching looked after the day-to-day management of the business and expanded the Hope Town operation by taking over a nearby foundry run by William Lister. The S&DR took an interest in the growing industrial complex around Hope Town and opened its own coach works there. Later, when looking for a site to start an engineering facility, the original Kitching factory was offered to the S&DR. This became the base of the North Road Locomotive Works.

The remaining Lister factory was developed and was renamed the Whessoe works. The business was by run Kitching's cousin Charles Lanson, leaving Alfred Kitching to concentrate on civic duties including as mayor in 1870. He also became a partner in Lanson's next business, the Rise Carr Rolling Mills, opened in the 1860s.

However, it was not from the railways that the outlook for the area was dramatically changed. It came from a Darlington resident and mining engineer, John Marley, who had been working with Bolckow and Vaughan, the iron founders in Middlesbrough, carrying out surveys to find local iron ore deposits. In the Cleveland Hills an abundant supply of ironstone was discovered and soon blast furnaces producing iron were constructed all along the Tees Valley. In Darlington land for an industrial base at Albert Hill was sold

Carriage works was opened in 1853 by the Stockton & Darlington Railway, now used to build and preserve steam locomotives.

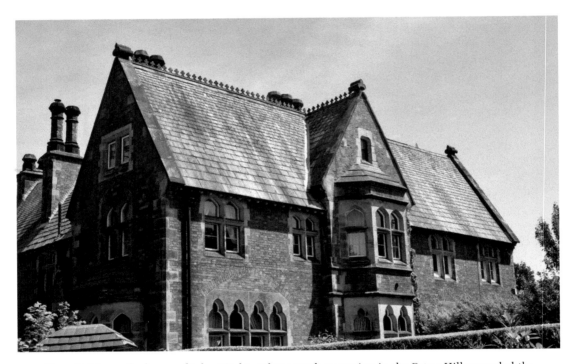

Thornfield was the home of John Marley, whose work surveying in the Eston Hills revealed the ironstone deposits that opened up the iron industry in the Tees Valley.

by the Allen family. The site was well placed alongside the railway lines running east to west and north to south, ideal for transport when the only alternative was a horse and cart. The Darlington Forge opened in 1854 followed by the South Durham Iron Works, whose blast furnaces produced pig iron, much of which was bought by the Darlington

Iron Company to produce rails. This company also opened the Springfield Iron Works, which was connected to the Albert Hill site by the five-arch bridge across the Skerne.

Housing was soon springing up around these factories. New streets appeared in the Albert Hill area, among them Killinghall, Vulcan, Cleveland and Howard streets. Some of the new homes were taken by families moving into the town from all parts of the country, attracted by the work that was available. This included a strong Irish presence; of the 283 people living in Howard Street in 1871 over 45 per cent were of Irish heritage.

Some of these ironworks did not survive. The South Durham Iron Company closed in 1880 and the Darlington Iron Company in 1894. However, it gave the opportunity for the Forge to expand its operations into part of the abandoned site. Summersons, which had opened in Albert Hill in the 1860, also took part of the vacant plot and continued making and installing railway equipment into the next century. Away from Albert Hill the Cleveland Bridge and Engineering Co. was opened in Smithfield Road in 1877. Whessoe was finding new markets and the railway works continued to expand.

While industry was stimulating the growth of the town, the local administration and governance had to respond to meet the demands of the changing times. In 1850 the lack of regulation that had allowed the poor conditions endured by many of the townsfolk to develop was highlighted. The Local Improvement Act was passed in 1823 and set up a local administration to bring improvements including the provision of lighting, paving and cleansing, but by 1850 it was criticised as being 'inadequate to prevent the very large amount of sickness [and] excess of premature mortality'. This was one of the conclusions of the report into the housing conditions found in Darlington. There was much wrong, although the problem was not unique to Darlington. Edwin Chadwick's Report on the Sanitary Conditions of the Labouring Poor highlighted the conditions faced throughout the country and led to the Public Health Act of 1848. This Act established a Central Board of Health that could provide inspectors to report on local conditions. William Ranger, an inspector from the Board, together with Darlington's Medical Officer, reviewed and described the situation in the town.

Some of the worst housing was on the eastern side of town, in an area that had once been part of the Bishop's Park. At Bank Top it was noted that houses were being built without drains. The town centre was not without problems including in Bakehouse Square, Houndgate and Skinnergate. The report includes some lurid accounts of the conditions in these areas, 'At present numerous dwellings are surrounded by fetid cesspools, abominable pig stys, open dung hills, dirty ditches and ponds of stagnant water, so that the ground is literally saturated with filthy ordures which often percolate into the springs and wells contaminating the water, or intrude through the adjacent houses staining the walls with offensive maters'. Poor ventilation and overcrowding were also problems. In one room measuring 14 feet by 12 feet a family of eleven were found. This included nine offspring ranging from a twenty-year-old daughter to an infant.

Life expectancy was low. In Park Street the average age at death was twenty-two, in Clay Row it was twenty-eight and Bakehouse Square it was only sixteen years. Away from the crowded housing things were better. In Harewood Hill the average lifespan was fifty years and fifty-three in Paradise Row (later Coniscliffe Road). These are average figures,

PUBLIC HEALTH ACT,
(11 & 12 Vict., Cap. 63.)

REPORT
TO THE

GENERAL BOARD OF HEALTH,
ON A

PRELIMINARY INQUIRY

INTO THE SEWERAGE, DRAINAGE, AND SUPPLY OF
WATER, AND THE SANITARY CONDITION
OF THE INHABITANTS

OF THE TOWN OF

DARLINGTON,
IN THE COUNTY OF DURHAM.

By WILLIAM RANGER, Esq.,
SUPERINTENDING INSPECTOR.

LONDON:
PRINTED BY W. CLOWES & SONS, STAMFORD STREET,
FOR HER MAJESTY'S STATIONERY OFFICE.
1850.

The Ranger Report highlighted the poor conditions in much of the town.

which include the effect of the terrible level of infant mortality. Longstaffe in his *History and Antiquities of the Parish of Darlington* was also aware of the conditions and described the situation on the east side of the river where 'Bishop's Park is now divided into fields, depressions have been filled in with bark and rubbish and on this decaying substructure streets have been built, the perpetual abode of fever and disease'.

The report concluded that there was preventable sickness in the town, that drainage needed to be provided to the backs of houses, cesspits should be abolished as should the flow of sewage into the Skerne as it passed through the town. The Gas and Water Company should supply running water to all households at a charge no higher than one and a half pence per week. The operation of the Local Improvement Act was criticised, described as ineffective and inadequate, and the report's recommendations included its replacement with a Local Board of Health to take control and responsibility for progressing the improvements needed.

The Board was duly formed. An early act was to have plans prepared for a replacement for the town hall and market shambles, which the report had condemned as 'unsuitable in point of size for the requisite purpose'. The new buildings were ready by 1861 and as part of the opening celebrations the arches under the market hall were used to hold a cattle and poultry show; visitors had to scramble for their life when part of the floor collapsed and one local farmer was killed. The repaired buildings still stand in the town centre with the grand Victorian Gothic clock tower paid for by Joseph Pease.

George Mason was appointed by the Board of Health and tasked with planning the provision of an adequate drainage system. He explained that to do this a water supply needed to be available to everyone, which meant the Board should take over the Darlington Water Company. This had been a Pease venture set up in 1849. Negotiations to purchase the company resulted in shareholders receiving £25 per share, many of whom were Peases, doubling their original investment. Of course this profiteering brought criticism of the Quaker family. Their affluence was on display in their houses. North Lodge, owned by John Beaumont Pease, is one example, as is Edward Pease's House in Northgate, described as having extensive gardens sloping down to the river with a bridge across to give access to Eastmount, the home of John Pease. Family members were beginning to move away from the centre of the expanding town to more rural areas, Henry Pease bought Pierremont, the grand house with extensive gardens that was originally the home of John Botcherley and Elm Ridge, which was built for John Pease in 1867.

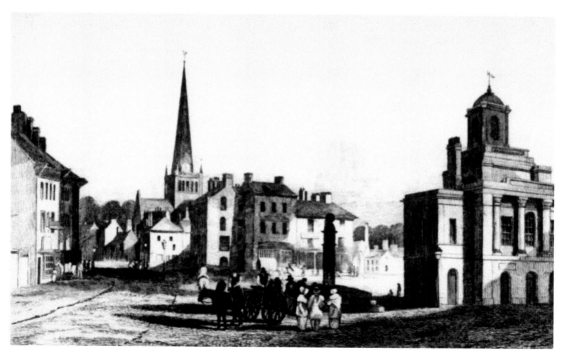

A sketch of the market area, c. 1830.

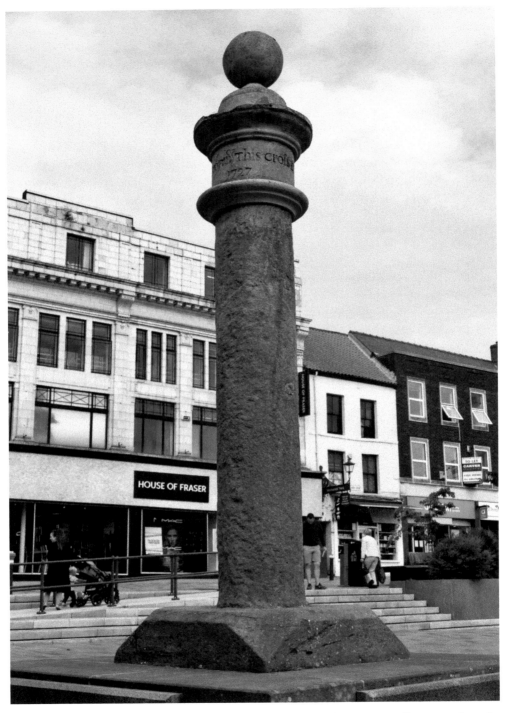

Dating from 1727, the market cross was shown in the sketch of 1830. It is still preserved on the southern site of the market.

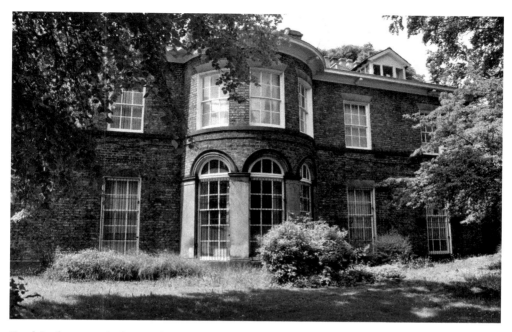

North Lodge, once the home of John Beaumont Pease and for a time in the twentieth century it was used as offices for the education committee.

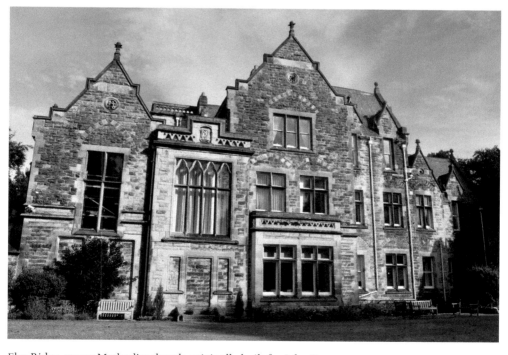

Elm Ridge, now a Methodist church, originally built for John Pease.

One thorn in the side of the Pease family was Nicholas Bragg. When he died in 1873 the obituary in the *Northern Echo* commented 'in the matter of the old Board of Health his firmness, we believe made him many enemies. In him the poor of Darlington have lost a friend'. His fight for reform had started with the Chartist movement, which had grown from discontent seen across the country in the early part of the century. The Reform Act of 1832 had brought hope of change. The Act corrected the unequal distribution of parliamentary seats and extended the vote to more men. Darlington became the centre of the new South Durham parliamentary constituency that returned two MPs. Celebrations in the town to mark the passing of the Act saw a procession leave from the town hall and local trades were represented including wool combers, bricklayers, coopers, coachmakers, farmers, curriers, tailors and railway men. The extension of the vote brought little benefit to most of those who had taken part as only five percent of men qualified to vote, leaving most without representation in a time of change and difficulty for many. The development of new industries, which took work into a factory environment, brought grievances over working conditions and long working hours. Attempts to form trade unions had been attacked, the Tolpuddle Martyrs being the famous example. New Poor Laws were introduced in 1834 bringing concern that families who needed to seek help would be forced to enter the workhouse and would be split as men and women were to be housed in separate parts of the building. Being subjected to the harsh regime of the workhouse made work, even at low pay, attractive but this could also be an incentive for employers to reduce wage levels. The Corn Laws kept the price of bread high by preventing the import of grain. There was disquiet and concern in the town. Meetings of the Anti-corn Law League were held, the linen trade was declining and workers in the flax factories were described in 1834 as 'the most distressed' and had to turn to the Poor Law to help subsidise low wages.

It was not surprising that there was support for a political crusade with a goal of achieving universal male suffrage, secret ballot, annual elections, equal constituencies, abolition of property qualifications for MPs and payment for MPs. By 1839 the Darlington Working Men's Association met to reorganise and support the Chartist movement. Meetings and gatherings of chartists were held in the town, and the local magistrates became concerned about the risk of disturbances and the possibility of violence. A number of special constables were appointed and a troop of soldiers was available to control public meetings. These soldiers were based in Stockton but could quickly be moved into Darlington along the railway.

Mr Oliver, a stationer, printer and newsagent, supported the Chartist movement and was well placed to have posters printed. One addressed to the middle classes of Darlington thundered, 'you are holding secret meetings, swearing in special constables, for the purpose of putting down our meetings, no doubt to drive us also to desperation and to riot so we may fall prey to police bludgeons [and] your soldiers bayonets'. Later, in 1839, John Batchelor, a chartist from Sunderland, was arrested at Mr Oliver's house accused of inciting the use of violence. Batchelor had told a meeting in Darlington to 'arm against the foreign and domestic foe'.

A report in the *Durham Advertiser* in May 1839 tells how Mr Coffey, an innkeeper in the town, allowed a meeting to take place on his premises. He provided supper

afterwards 'when ample justice was done to the good things provided ... so powerful was the attraction that many did not leave until the early hours'. Later in the year Coffey's application to renew his licence was refused as he had 'encouraged those poor ignorant people, called chartists, to frequent his house, and that he [the magistrate] considered he ought to be made an example of'.

The chartists opened a cooperative shop in Priestgate managed by Nicholas Bragg. A few months after opening the shop, Bragg was arrested for obstructing the thoroughfare by holding a public meeting in Market Place on Easter Tuesday. He was fined £5 or three months in jail; the cooperative store's funds were to be used to pay the fine but while the money was found he spent time in Durham Gaol. The chartists were able to use this as an opportunity to publicise the poor conditions that he had been subjected to in Durham: 'for breakfast they had coarse brown bread and skilly (a thin porridge), the latter so nauseous looking that they begged to be allowed water'.

By mid-century the Chartist movement had declined – the possibility of a national, unified movement that was predominately working class and could prompt political change had faltered. However, Nicholas Bragg did not lose his energy to seek reform and campaigned against the clique, which included the Pease family, that was dominating the Board of Health. In 1861 he harangued Board members for acting illegally and using their position for personal gain. He was aware that thousands of pounds had been paid to members for supplying goods to the Board despite the Public Health Act outlawing this. He gave one example of a payment of £80 to Joseph Pease for supplying drain pipes to the Board. Then he turned on Robert Thompson, who justified the Board paying for a wall that had been built in Houndgate as an improvement for the town even though it was enclosing Thompson's property. Nicholas went on to tell how traders were being excluded from lucrative contracts by impossible conditions being imposed. One involved the supply of bricks. A Mr Robson had submitted the lowest price for the production of 300,000 but could not meet the delivery date that was then demanded. Bragg suggested that the tight delivery schedule was not to meet building schedules but to protect brickyards favoured by the Board.

He was not alone in his concern. Henry King Spark fought for reform and they both stood for election to the Board without success, the voting system ensuring the status quo was maintained. There was a very restricted number of people able to vote in elections for Board members; in 1862 there were only 1,234 and many, like Joseph Pease, had plural votes, ten for his property and twelve on behalf of the S&DR.

The movement for reform gathered pace and it became recognised that Board of Health was not the body that could be properly responsible for so much administration in the growing town. Even one member of the Board proposed that a corporation should be formed. This was voted down but agitation continued. Henry King was elected to lead a committee for incorporation, petitions were signed by the majority of rate payers and a government commissioner held an inquiry in 1867, which resulted in Darlington Borough Council being formed with council members elected for each of the six newly defined wards. Householders were given a vote and the number of votes increased to around 5,000 but many of the old guard were still elected and seven members from the old Board and five Peases had seats on the new corporation.

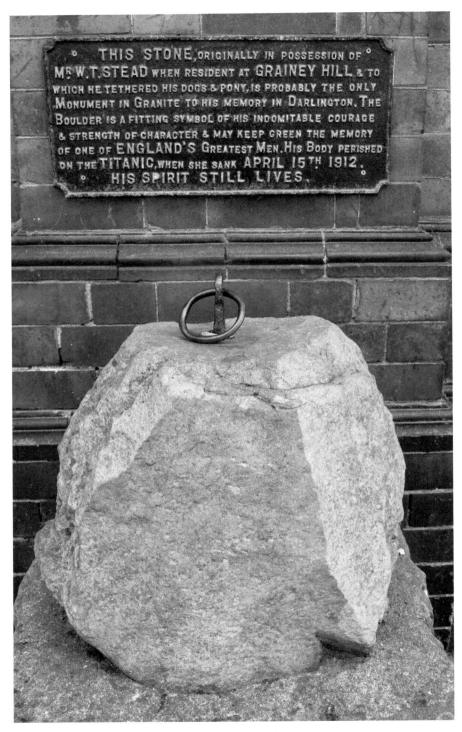

THIS STONE, ORIGINALLY IN POSSESSION OF
MR. W.T. STEAD WHEN RESIDENT AT GRAINEY HILL, & TO
WHICH HE TETHERED HIS DOGS & PONY, IS PROBABLY THE ONLY
MONUMENT IN GRANITE TO HIS MEMORY IN DARLINGTON. THE
BOULDER IS A FITTING SYMBOL OF HIS INDOMITABLE COURAGE
& STRENGTH OF CHARACTER & MAY KEEP GREEN THE MEMORY
OF ONE OF ENGLAND'S GREATEST MEN. HIS BODY PERISHED
ON THE TITANIC, WHEN SHE SANK APRIL 15TH 1912.
HIS SPIRIT STILL LIVES.

This memorial to William Stead stands outside the library in Crown Street.

Henry Spark had used the *Darlington and Stockton Times* to campaign against the Quaker dominance of the Board of Health and the need for a more representative administration that a borough corporation would bring. He bought the newspaper in 1865, although since its foundation in 1847 it had highlighted the need for progress. In 1849 an editorial demanded action to improve public health in the 'filthy un-drained streets, the ill-ventilated houses and other abominations which prevail in some parts of our town'.

Founded later than the *Darlington and Stockton Times*, the *Northern Echo* appeared in 1870 and was the first daily morning newspaper in the country to sell for a half penny. It would soon become known for its campaigning journalism under its editor William Stead. Stead reported on the atrocities suffered by the Bulgarian people when they rose up against Turkish rule, writing of 'blazing villages, massacred multitudes, enslaved children, outraged maidens'. This exposure in the *Northern Echo* started to influence public opinion and fuelled a growing demand that the Conservative party and its leader, Disraeli, should condemn Turkey and withdraw support for the regime. The influence and reputation of the paper was reaching beyond the north east. The Liberal leader Gladstone is said to have commented, 'it is with sincere regret that I cannot read more of the *Echo* for to read the *Echo* is to dispense with the necessity of other papers'. Stead's campaigning journalism in Darlington brought him the opportunity to move to London as assistant editor of the *Pall Mall Gazette*, where he pioneered investigative journalism. His revelations about child prostitution and procurement, published under the title 'The Modern Tribute to Babylon', portrayed horrific details of the trade in young girls. To illustrate how it was organised he bought a thirteen-year-old girl, Eliza Armstrong, for £5. Once rescued he took her to be looked after by the Salvation Army but for his trouble William was jailed for three months for abduction. William was one of the many passengers lost on the *Titanic*.

The *Darlington and Stockton Times* and the *Northern Echo* became established newspapers but others, often with short lives, had been published including the *Darlington Mercury* in 1772, *Northern Express* in 1855, the *Darlington Telegraph* in 1854 and the *Darlington Telegram* from 1858.

5

Education and Entertainment

By the end of the nineteenth century Darlington was no longer a small town huddled around a marketplace. New streets appeared on both sides of North Road stretching from the locomotive works towards Harrowgate Hill including Wales and Westmoreland streets and on the east side Katherine and Aldam streets. The central area was growing and to the east, beyond Bank Top housing, was spreading along Yarm Road where there was also a new workhouse opened in 1870. This replaced the Bishop's Palace, which was demolished. There was limited development on the west side with some substantial houses around Coniscliffe Road. Cockerton was being approached by developments along Woodlands Road. Nevertheless, like Haughton and Blackwell, Cockerton remained a separate village. Statements of Victorian pride, achievement and wealth such as the library, Barclays Bank, the County Court and the Technical College contrasted with rows of working-class terraces.

By the late nineteenth century grand houses were being built in the west end of town. William Moscrop was a partner in the firm of architects that designed these houses in Ashcroft Road. He appears to have been so impressed with the design that he bought one.

In contrast to Ashcroft Road are these houses off North Road that were close to the railway workshops and the industry in Albert Hill.

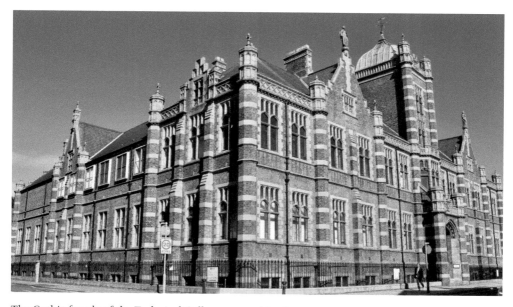

The Gothic façade of the Technical College, opened in 1897.

The changing times brought the move towards universal education. The opportunity for education was expanding with provision by a number of providers including the church, charities and private enterprise before the state stepped in to provide school places for children. The grammar school is the earliest school recorded in the town. It was given a royal charter in 1563 by Elizabeth I, although it had been founded a few years earlier by Robert Marshall from Cockerton, who gave the rental income from land in Heighington and Thornaby and from houses in Darlington to fund the school and pay a teacher. Initially teaching was undertaken in a corner of St Cuthbert's Church. Later a schoolhouse was built in the grounds of St Cuthbert's, and then in 1816 it was moved to a spot by the Southern boundary of the churchyard. The school struggled during the nineteenth century; one errant headmaster had to be dismissed and the location in the centre of town near the streets and yards that the Ranger Report had found in such poor condition did little to attract pupils. The school was closed in 1874 and did not reopen until 1878 when a new building was completed in Vane Terrace.

Other schools were also funded by endowments. In 1713 Dame Mary Calverley left £1,000 to school the poor of Darlington in the principles of Christian religion, to teach them to read and write and provide clothing.

For those able and willing to pay there were fee-paying schools. In 1820 there was an advertisement for a Select Ladies School in Darlington, which told that 'Misses M and A Simpson will educate a limited number of young ladies, to whose improvement, comfort and general happiness they devote their whole attention, aided by the best masters. There are no vacations and terms are very moderate. Further information may be had of Mr L Simpson who attends from twelve to two daily at Saracen's Head, Snow Hill'.

For some time the Grammar School was at the boundary of St Cuthbert's churchyard. The site is recorded on this plaque placed near the footbridge across the river.

In his book *The Life and Adventures of Nicholas Nickleby* (1838) Charles Dickens introduced the school near Barnard Castle with an advertisement of its services. 'At Mr Wackford Squeers's Academy ... in Yorkshire, youth are boarded, clothed, booked and furnished with pocket money and all necessaries. Terms twenty guineas per annum. No extras, no vacations and diet unparalleled. Mr Squires is in town and attends daily at the Saracen's Head, Snow Hill'. Whether the Simpsons' school had the same doubtful ethics as Dicken's Dotheboys Hall cannot be commented on but it is interesting to note that both schools boasted no vacations, providing a hideaway for unwanted children.

Sunday schools were significant in the development of education, particularly for the working classes where children were needed to contribute to the family's income and Sunday was the only time available. In 1823 there were children at work in Darlington and it was noted 'no less than 1,000 looms are constantly employed here ... occasions daily work for multitudes of dyers, spinners, combers and children who wind the thread and yarn'.

The first Sunday school seems to have been opened by Revd Topham of St Cuthbert's Church. There was a restricted curriculum and reverend advised that teaching should be limited to 'reading [the] Bible, spelling, together with the church catechism ... and other religious books as may be necessary for promoting Christian knowledge. Writing not important as in the first two years on account of the children being very young and their time occupied in learning the rudiments of the English tongue'. An early attempt by the Methodists to run a Sunday school in the church in Bondgate seems to have failed because of poor behaviour on the part of the children attending.

Haughton Methodist Church opened in 1825 with a reminder of Sunday schools.

The provision of education took a step forward in 1808 when the British and Foreign Society (British Society) was founded with the aim of providing education for the poorer members of society. Teaching costs were kept to a minimum by the use of monitors. Under this system the schoolmaster would teach the older children, who would then pass on the knowledge and drill a group of younger children. The British Society was non-denominational and not being aligned to any one church group could not rely on funding from church sources, although in Darlington the Methodists and Quakers provided support. The statue of Joseph Pease in the town centre has a reminder of the contribution he made to education in the town. The first British School was opened in Skinnergate, followed by Bridge Street in 1834, then in Feethams, Kendrew Street, Denmark Street, Bank Top, Rise Carr and Albert Road.

The established church, fearing that the 'great body of the nation society be educated in principles other than those of the established church', reacted to the work of the British Schools and in 1811 formed the National Society to provide Church of England schools for the poor with some funding available from the parish. The first National School was opened in 1812 in the grounds of St Cuthbert's. This was followed by schools provided by other churches around the town. Holy Trinity had schools in Commercial Street and Union Street, St John's had a school by 1860 and in 1863 a school associated with St Paul's was opened in Westmorland Street. The Catholic community also built schools, first in the grounds of St Augustine's Church, then in Brunswick Street in 1859 and with the growing numbers of Irish people in the Albert Hill area a school in Barton Street in 1871.

Eventually the importance of education was recognised by the government and some funding was made available each year to be distributed to the National Society and the British Society. As the century progressed it was realised that if the country was to remain at the forefront of industrial development an educated workforce was needed. The 1870

A reminder of the town's first British School, opened in Skinnergate in 1819.

Education Act introduced School Boards, which were to be responsible for provision of elementary education. Darlington already had a number of schools established by the two voluntary groups but the School Board was set up in 1871 to ensure that adequate places were available throughout the town. Attendance was not compulsory and one of the responsibilities given to boards was to encourage parents to send children to school. The Church of England and Catholic bodies continued to provide schools, but the School Board was extending its influence taking over schools and building new facilities. These included Beaumont Street in the town centre, Corporation Road and Rise Carr schools.

Right: An annexe was built in Lowson Street for St Paul's School. It was taken over by the School Board in 1879.

Below: Rise Carr School was one of the first to be built by Darlington's School Board.

While these schools provided elementary education for boys and girls, the opportunity for girls to continue their education as boys could at the grammar school was provided in 1885 when the high school for girls was opened at Claremont in Trinity Road. Another secondary school was opened in 1904 by St Augustine's Catholic Church, which soon took over Southend, once the home of Joseph Pease.

Left: Claremont, the first home of Darlington High School for Girls.

Below: Southend, once home for a member of the Pease family, became the Catholic Grammar School for girls in 1904.

There was a growing need for teachers. To cater for this the British Society opened a college in Vane Terrace to train female teachers in 1872. The area around Vane Terrace was becoming a centre of learning, with the new building for the Grammar School next to the teacher training college and the High School around the corner.

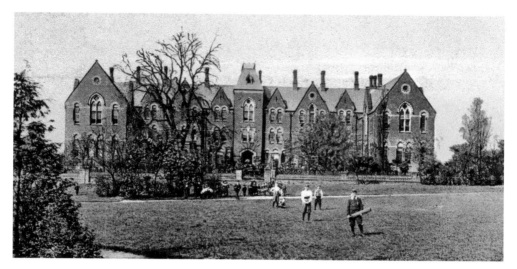

The teacher training college in Vane Terrace.

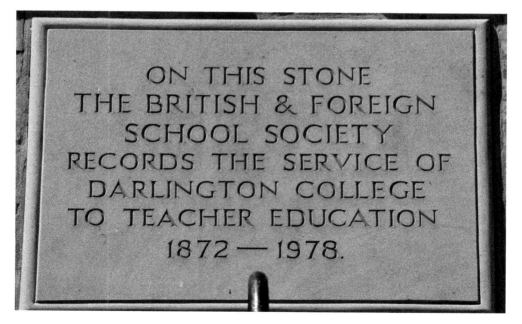

ON THIS STONE
THE BRITISH & FOREIGN
SCHOOL SOCIETY
RECORDS THE SERVICE OF
DARLINGTON COLLEGE
TO TEACHER EDUCATION
1872 — 1978.

The teacher training college building has been converted to flats but this plaque above the main entrance records its original function.

Much of the focus by the state was to provide elementary education for children between the ages of five and thirteen. One forerunner of the provision of education past this level was the Mechanics' Institute, which was formed in 1824, with the support of the Pease and Backhouse families, although by 1827 there was little support and it took until 1840 to be revived. A speaker in 1847 provided a reminder of the aims of the institute when he reflected that a 'man begins to learn a trade and his education in numberless cases ceases' and this must not be right as 'there is a duty to improve ourselves'. The institute provided scientific education including night classes, all very worthy but not supported by large numbers. In 1896 the membership was 789, which included forty-three ladies, seventy-eight merchants and gentlemen, 145 tradesmen, 169 clerks and 121 mechanics. However, it must be remembered that it could take determination on the part of working folk to devote time to study when the working hours could be long. The North Road Locomotive works in the early days had a fifty-nine-hour week, with work from Monday to Friday starting at 6 a.m. and finishing at 6 p.m., with breaks for breakfast and lunch. On Saturday things were a little easier with a 6 a.m. start but a finish at 1 p.m.

There was also an expansion of leisure facilities with plenty of diversions available for those not inclined to continue their education, although some of the unsavoury activities had disappeared. Bull-baiting was stopped in the 1790s, and cock fighting was regularly advertised in the town during the eighteenth century before it was banned in 1835. Village feasts were ancient festivals, Cockerton feast surviving into the twentieth century.

This was the Mechanics' Institute in Skinnergate, opened in 1854.

By the 1850s there were eighty public houses and beer shops. The Temperance Society was promoting a similar message to Longstaffe, who warned that 'income spent on drink, reduces the respectability of the household'.

Sporting pastimes included cricket. In 1873 a team of eighteen from Darlington and District played at the Feethams ground against eleven of the United South of England team, which included W. G. Grace, the iconic player who did so much to popularise cricket. Darlington, with the advantage of a team fifty percent larger than their rivals, won the three-day match. Football had been played in the town for some years and in 1883 the Darlington Football Club was founded. An early member of the team that played at the Feethams ground was Arthur Wharton, who was in Darlington training as a missionary. His skill brought a transfer to a Newcastle team and in 1889 became the first

From the 1830s a Temperance Society was active fighting to 'diminish the consumption of spirit and the dreadful evil of intemperance'. This drinking fountain was erected in Bondgate by the society in 1862 and moved to the South Park in 1875.

Arthur Wharton played football for Darlington's amateur team and went on to become a professional footballer.

black professional footballer when he joined Rotherham F.C. The Darlington team did turn professional later, joining the North Eastern league in 1908.

The Darlington Bicycle Club was formed in 1876, with members wearing the club uniform, which by 1883 consisted of blue serge jacket trimmed with military braid, cord breeches and a polo cap. A fine group of men taking to the roads on their outings, Northallerton being among their favoured destinations. The safety bicycle, with its two wheels of the same size, which made it much more stable than the penny farthing, was developed during the 1880s and cycling gained popularity. By 1896 there were more clubs including St Hilda's, North End and St Cuthbert's organising rides into the countryside.

There were entrepreneurs ready to provide entertainment including the circus, which was a regular visitor. In 1853 William Cooke's Circus brought elephants and clowns and in 1860 the antics of the bull Don Juan of Wallett's Circus was reported to have 'afforded much entertainment'.

The Theatre Royal in Northgate had opened in 1875. However, the 1,200-seater theatre was severely damaged in 1883 and had to be rebuilt. Fire damage was not unique; the wooden stages and the naked flames used to light the stage brought disaster to other theatres.

For the less energetic the railway was ready to whisk people off to the seaside or into the country. Excursion were running to the developing resorts of Redcar and Saltburn or into the countryside to visit Barnard Castle, Cotherstone or Middleton in Teesdale. Parks were available. Bellasses Park was opened in 1853 on land donated by Sir James Bellasses, later renamed the South Park when the grounds were extended with tennis courts, a bandstand and in 1908 a café. North Park was set out on land bought by the council in 1894. North Lodge Park was formed from the gardens of two Quaker mansions, Elmfield and North Lodge.

The South Park was opened in 1853. In 1899 the *Darlington and Stockton Times* described it as 'the pride of the townspeople – no better kept park in the North of England'.

Whilst the South Park was the forerunner, more followed: Stanhope Park in 1878; North Park in 1896; and, in the next century, Sugar Hill in 1922; and Alderman Crooks' Park in 1935.

6

Into a New Century

The nineteenth century had brought dramatic change to the town, and the next century would be no different. However, in the early years of the twentieth century the established engineering base continued to provide employment and attract new business. Disruption came with the two world wars and the economic depression of the interwar years but it was later that structural change saw many of the traditional industries disappear. Also fading was the position of the Pease family and its business empire. Another transport revolution was on the way and motor vehicles would threaten the dominance of the railways.

The town's public transport gave way to motor transport, evolving from horse-drawn trams and electrically powered buses. As early as 1862 there had been a service available when a short-lived tram service with horse-drawn vehicles pulled along rails sunk into the road. Another operator started in 1880 with routes along Northgate and towards Cockerton but it was in 1904 that the town's first electric trams were introduced, with motors powered by electricity collected from overhead lines. Trolley buses followed. These still used overhead power lines but did not need the rail lines as they were equipped with steering and tyres. Motor buses were soon to take over, having had the advantage of not being restricted by the availability of the power cables, and by 1957 the trolley buses had gone.

In the early twentieth century there were still fields in the Feethams area.

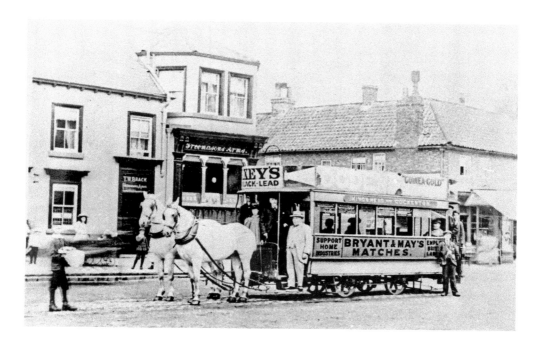

Above: An early horse-drawn tram service.
(Courtesy of Beamish Collection)

Right: Crowds in High Row and Prebend
Row gathered for the opening ceremony of
the Darlington Corporation's tram service.

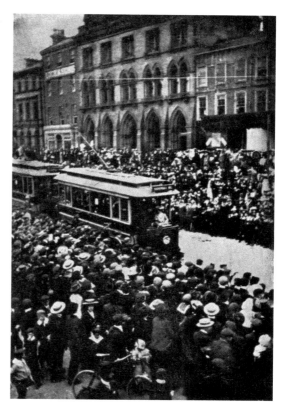

Education continued to be developed. The 1902 Education Act focussed on secondary provision. By the late nineteenth century Darlington had started to develop education beyond the elementary level. The Technical College was opened in 1897. A school opened in Gladstone Street in 1911 offered a three-year course for twelve to fifteen year olds. This became the Central Secondary School. Secondary education was developed further at the North Road school with a catchment from the Albert Hill and Rise Carr areas. The Harrowgate Hill school was also devoted to older pupils as was the Beaumont Street school until 1935 when the senior school at Eastbourne was opened. Some of the voluntary schools provided teaching past the primary level including the Holy Trinity School, although these were gradually taken into the control of the local authority. The Grammar School was extended and the Girls' High School moved to larger accommodation in Cleveland Avenue in 1911.

The move to comprehensive education brought significant change, although an early attempt to introduce a piecemeal change brought controversy. In 1959 a school being built in Branksome was earmarked to be opened as a comprehensive. This brought uproar from the parents of pupils in the junior schools that would feed this school, concerned that their children would be deprived of the opportunity to attend the grammar or high schools, which would remain available to the rest of the town. The plan was rejected by the Education Minister. The introduction of comprehensive education across the town had to wait until 1968. The Girls' High School, which had moved to Hummersknott in 1955, became a comprehensive along

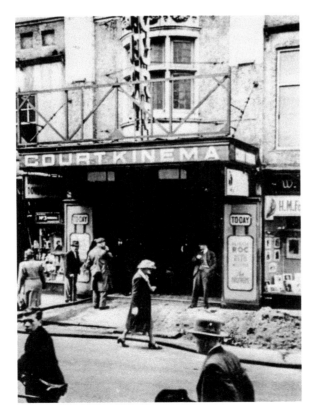

This cinema in Skinnergate was opened in 1913 but destroyed by fire in 1947. (cinematreasures.org)

with the senior schools at Eastbourne, Longfield Road, Haughton, Carmel and Branksome. The Grammar School changed to become the town's sixth form college.

Entertainment brought new wonders. In 1897 the 'first appearance of the latest wonderful invention', 'The Cinematographe', with 'living moving pictures' was advertised. The pictures shown included the interior of a Blacksmith's shop, Henley Regatta, Persimmon winning the Derby and a re-enactment of the execution of Mary Queen of Scots. 'The realistic and lifelike manner in which the figures were exposed was little short of marvellous' gushed a local report. The display was shown at the Central Hall, which soon became used as the town's early cinema. The first purpose-built cinema was the Empire, which was opened in 1911 in Quebec Street. Skinnergate became the home for two cinemas, the Court and the Arcade. More followed including a second surge in building in the 1930s that included the rebuilding of the town's oldest theatre in Northgate (the Theatre Royal) into a cinema in 1938 and the opening of the Regent in Cobden Street in 1939. This allowed Darlington to boast the most cinema seats per head of population in the country, although this record only lasted until fire destroyed the Court Kinema in 1947. Most of the old cinemas have gone, forced into closure by the progress of television.

This was another cinema in Skinnergate. Opened as the Arcade Cinema in 1912, in 1956 it became the Majestic dance hall until bingo took over.

The cinema in Eldon Street operated until 1962. It had the benefit of a fish and chip shop next door ready to provide supper as the cinemagoers left.

The Hippodrome theatre did show films to supplement the variety acts for a short time but has survived as a theatre. Signor Pepi opened the Hippodrome in Parkgate in 1907. He had been a star of the stage in Britain and Europe before turning his attention to theatre management. There were a number of local groups that provided opportunities for amateur thespians to display their talents in the theatres. The Darlington Dramatic Club and the branch of the British Empire Shakespeare Society provided an outlet for budding actors. In 1912 the Darlington Dramatic and Operatic Society was formed and gave performances in the Hippodrome theatre. Another group, the Darlington Operatic Society, followed and produced Gilbert and Sullivan's *HMS Pinafore* in the Theatre Royal. The Second World War brought an end to these productions until a number of those involved in the pre-war groups founded the Darlington Operatic and Choral Society in 1945. Since then this group has been closely associated with the Hippodrome and played a part in saving the theatre in the 1950s when it was threatened with closure. With some breaks when the theatre was closed for renovation, the society has continued to bring musicals to the town.

In the world of work the town was still heavily involved in engineering and the iron and steel trades, the Forge was producing castings for railways and ships. The Cleveland Bridge was receiving orders from across the world. Whessoe had been reformed with new ownership and found opportunities in the growing oil business producing storage tanks. The Rise Carr Rolling Mills had also found new funding and was stating to produce

steel sections. The railways brought more work. In March 1900 it was announced that the construction of a new locomotive works in Springfield had started for Robert Stephenson Ltd. The firm, based in Newcastle, had been started in 1823 by George and Robert Stephenson and Edward Pease. However, by the late nineteenth century the factory needed refurbishing and investment in new equipment. With the lease expiring it was decided that a new, modern building was needed.

Above: A scene from Darlington Operatic Society's production of *Chitty Chitty Bang Bang*. (Courtesy of Darlington Operatic Society)

Right: Darlington Forge at work. (Courtesy of Centre for Local Studies, Darlington Library)

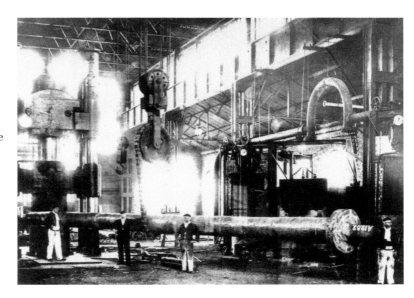

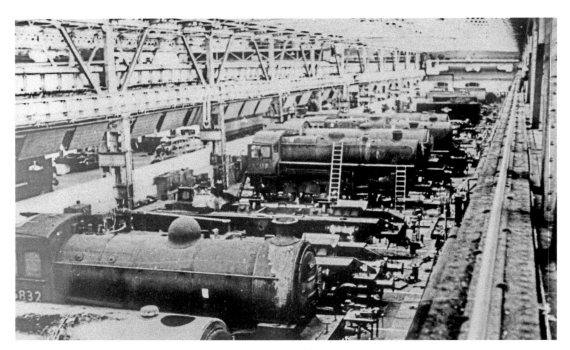

Work on steam locomotives in the North Road Locomotive works. (Courtesy of Beamish Collection)

Wylam Avenue, wide enough to cater for deliveries and the flow workers heading for Robert Stephenson Locomotive works.

The early years of the twentieth century did not start well for the Pease businesses. This followed a damaging dispute in the family, which had started in the 1890s and involved the release of the inheritance to Beatrice, the niece of Sir Joseph Whitwell Pease. Beatrice married the Earl of Portsmouth and looked to have her inheritance paid, much of which was invested in Pease collieries. Sir Joseph advised that it was not a good time to sell these investments as the coal trade was depressed and the price would be low. Not accepting this, the couple took legal action and the ruling by the court was in favour of Beatrice, leaving Sir Joseph having to find around £250,000. He did not have this cash available and to raise funds he arranged for shares in the business of Pease and Partners Ltd to be sold to the public. This issue of shares to the public considerably reduced the proportion of the company that the Pease family held in this industrial conglomerate, which in 1902 was reported to have ten collieries, three ironstone mines, 1,866 coke ovens, own 2,000 workmen's houses and employ 6,000. During the court case the integrity of Sir Joseph advise against selling investments was brought into question. More problems followed and the position of the Peases in the industrial and commercial world was damaged.

The bank of J. and J. W. Pease, an undertaking separate from Pease and Partners, was operated by Sir Joseph and his sons Arthur Edward and Joseph Albert as a partnership. This was no longer the regular way to operate a bank. The large banking groups with vast financial resources were spreading across the country and negotiations were started with Barclays to take the Pease bank into its fold. Things were progressing well and in 1902 Barclays agreed to fund the Pease Bank with £160,000. This was needed to ensure the bank had enough liquidity to pay the North Eastern Railway's (NER) dividend that was due on 23 August. The Pease bank had normally used other banks including the National Provincial for this type of short-term funding but as Barclays were involved, they had not sought the funding elsewhere. In the meantime an accountant had been asked by Barclays to review the Pease Bank's accounts and on 22 August reported that the bank was insolvent and could not cover repayment of all deposits. The proposed merger was abandoned, the three partners were forced to accept that Barclays would take over the banking business of J. W. and W. Pease but not the liabilities. The partners were now left with personal liability for the bank's debts. They had to sell their assets to repay those who had lost money, which included deposits of £231,995 in the NER account. Shares in Pease and Partners were sold as were the interests Henry Pease & Co., which owned the original textile business based in the Darlington mills. Property had to be sold including Joseph Whitwell's estate at Hutton near Guisborough. Eventually those owed money received a payment of forty-two pence for each pound owed.

In 1901 the financial world was also proving a catastrophe for a Darlington man when in front of a crowded court, he was sentenced to five years in jail for fraud. John Hall had been in business since 1878 as a stock broker and had built up a considerable business and reputation for reliability and integrity. But John's speculation in the stock market led to disaster and he used clients' money to cover his losses. He was faced with demands for the return of money that had been deposited with him, but the money had gone and facing arrest, he fled. First to Dublin then he took a ship to New York using the name John Harris. However, on board the ship he was recognised by a fellow Darlingtonian. Police followed him to New York and arranged for his extradition. In August 1901 he was greeted at Darlington station by a crowd wanting to witness the return of this discredited figure who had been a

leading light in the town as chairman of the Darlington School Board, a local magistrate, a lay preacher and church warden at Holy Trinity Church. At the trial, at which Hall pleaded guilty, it was suggested that up to £15,000 had been lost and the judge condemned him for the abuse of the trust that had been expected of him by innocent people.

Evidence of more financial troubles could be expected during the interwar years, a time of economic depression, unemployment and the general strike. In 1933 J. B. Priestley wrote about the distress the depression was causing in his book *English Journey,* which included a visit to Stockton-on-Tees where he found 'shipyards that had been closed for years, so that grass is growing on them … and marine engineering shops that are now empty shells'. In contrast he saw that Darlington was not so badly affected and commented it was 'still enjoying the favours of the London North Eastern Railway (LNER)'. The railways had brought more work into the town. In Brinkburn Road the new offices had been built to house regional engineering headquarters of the North Eastern Railway (NER), which had absorbed the S&DR and itself would become part of the LNER in 1923. Wagon works were opened in Faverdale in 1923 that was capable of building 10,000 wagons a year, adding to the considerable employment already provided by the railways. However, it is wrong to take away the impression from Priestley's words that the town avoided the misery caused by the economic depression of these years. The LNER was not immune to the situation and in 1930 made cuts at the locomotive works where 357 were made redundant and at the wagon works ninety-five were given notice.

Other Darlington firms had to face the challenges of this period, including, from its headquarters in Northgate, Pease and Partners Ltd with its interest in collieries, coke, ironstone, and steel. The mines, as a strategic industry, had been taken over by the government during the First World War and not returned to the owners until 1921. By this time the post-war boom was ending. The export market for coal was contracting as European mines were reopened. To keep coal prices at a competitive level, attempts to reduce wages were met by strike action, Mines were closed throughout the country for three months in 1921. At the Annual General Meeting of Pease and Partners in 1921, Sir Arthur Pease explained that trading conditions were becoming difficult and if costs were not reduced to meet foreign competition problems would follow. 'Workmen should take lower wages now and employers take little or no profit'.

The disputes over wage rates and the price that could be obtained for coal rumbled on for years. The general strike of 1926 only lasted for days but the miners' action went on much longer. Trading continued to be difficult for the Pease business. The Lackenby Iron Works in Teesside were mothballed in 1923, mines were closed, 1,500 miners were given notice at Eldon Colliery near Bishop Auckland and at Christmas 1930 some office staff in Darlington lost their jobs. The company was making losses and rumours were circulating in the financial press of liquidation. Closure was a real possibility. Drastic action was needed and in 1931 an arrangement was accepted by the firm's creditors and shareholders. Most payments to those who were owed money, totalling around £1.6 million, were stopped and were converted to loans, shareholders forfeited a large proportion of their holdings and the management of the business was reorganised. Gradually the company was turned around and by 1937 was back in profit, able to repay the loans, and for the first time since 1925 paid a dividend to shareholders.

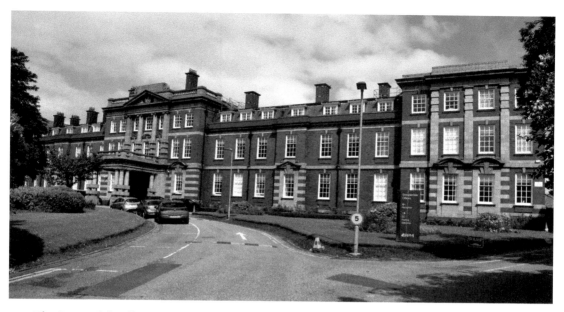

The Stooperdale offices in Brinkburn Road were built in 1911 for the North Eastern Railway (NER).

The intertwined initials of the NER are retained on the entrance gates to the Stooperdale offices.

The grand offices of Pease & Co. that once stood in Northgate. (Courtesy of Centre for Local Studies, Darlington Library)

The Darlington Forge also had difficulty finding orders and was closed down in 1932. It had made castings for the majestic liners such as the *Mauretania* and *Aquitania* for the White Star Line and Cunard's *Olympic* and *Britannic* and in 1913 employed around 1,300. Once the post-war demand for new ships to replace losses during the First World War had declined, the shipbuilding yards found few orders; in 1920 United Kingdom yard built around 2 million tons of shipping, but by 1932 it was down to 188,000 tons and the Forge ran out of work. However, by 1936 the improving economy brought new orders for the plant, which was reopened and a steady flow of work reported.

Darlington's housebuilders, despite a slow start, were busy during the interwar years. There was pressure to build more homes coming from two directions. During the First World War, the medical examination of recruits had revealed many unfit for service and the poor living conditions that many faced contributed to this. Houses that were habitable had to be built to make, as Lloyd George had promised, a 'land fit for heroes to live in'. Darlington had its share of poor-quality housing needing replacement and work on clearing the slum housing had started in the 1930s in the Park Street and the Bank Top areas but of course new houses were needed to replace these. There was also the influx of people brought by the opening of the wagon works in Faverdale and transfer of staff to the railway's Stooperdale offices and the Stephensons locomotive works. Developers submitted plans for new houses – only fifty-six in 1919. This was not going to solve the problem but by 1929 it had risen to over 400. In the 1930s building gathered pace with plans drawn up for over 900 in 1933.

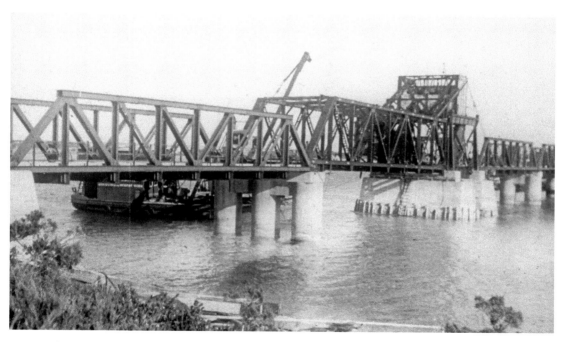

Produced by Cleveland Bridge, the bridge to St David's Island in Bermuda was opened in 1934. (Courtesy of Beamish Collection)

There was a range of local builders. Some operated in a small way using funds from the sale of completed houses on one plot to finance the next, while others were able to finance larger housing schemes. The Leas in Harrowgate Hill is an example with Bussey and Armstrong, who were building throughout the town starting work on fifty plots in 1925. Other builders were also working in the street including J. F. Davison, who built four houses, and F. Burton, who built eight. All were designed by the architect J. E. Charlton, whose work is seen in many of the houses built during these years. The growth in the building of new homes in the 1930s was encouraged by falling interest rates coupled with building societies starting to reduce the level of deposits from 25 per cent to 5 per cent, making mortgages affordable and accessible.

The legacy of house building between the wars can be seen throughout the town. Many were semi-detached houses with gardens at the front and rear in tree-lined streets, some spaced far enough apart to allow garages. A few display modern design trends with flat roofs and horizontal features decorating the walls. The local authority also had to act and started building houses for rent. Among these were developments in Cockerton, Harrowgate Hill and Geneva Road.

Builders were not solely working on new housing schemes. Binns department store was extended in High Row, bank premises were built on the corner of Prospect Place and Northgate (now HSBC), and churches were also built to serve the new communities. St Thomas Aquinas was opened near Thompson Street in 1926, All Saints in Blackwell in 1937, St Herbert's was started in Eastbourne in 1939 and Elm Ridge, once the grand Quaker house, was converted by the Methodists in 1932. The town gained some notoriety when Robert Jardine, the vicar at St Paul's Church, went missing in June 1937. He turned up at the Chateau de Cande, near Tours in France, and performed the wedding ceremony for Edward

The Leas, a typical interwar tree-lined street of semi-detached houses.

An example of a distinctive modern-style house built in the years between the wars.

and Mrs Simpson despite the refusal by the Church of England to sanction the marriage. Mrs. Simpson was an American divorcee and she had to go through a second divorce to be able to marry the Prince of Wales. When the prince became Edward VIII in 1936 a political crisis developed. The establishment reacted against Edward's plans to marry Mrs Simpson as her background was considered unsuitable. There was also concern about her sympathy towards the Nazi regime in Germany. In December 1936 Edward abdicated and broadcast to the nation explaining that he could not undertake his duties without the woman he loved. Jardine seems to have made full use of the opportunity for fame that followed his role in the marriage and by July he was in New York at the start of a lecture tour of America.

By 1939 the threat of war was looming and attention turned to building air-raid shelters, and first-aid posts. In the town centre shops that were once household names that have now disappeared such as Woolworths and British Home Stores had plans prepared for air-raid shelters. A band of volunteers was formed to implement the air-raid precautions including the blackout that required lights in homes, offices and factories to be hidden by curtains and shutters to avoid enemy aircraft identifying conurbations.

Right: St Paul's Church in North Road was closed in 1972. Its fate was sealed in 1973 when it was badly damaged by fire and by 1980 the development of the site for housing had started. (Courtesy of Centre for Local Studies, Darlington Library)

Below: There has been a market in the town for centuries; here a busy day in the 1930s. (Courtesy of Beamish Collection)

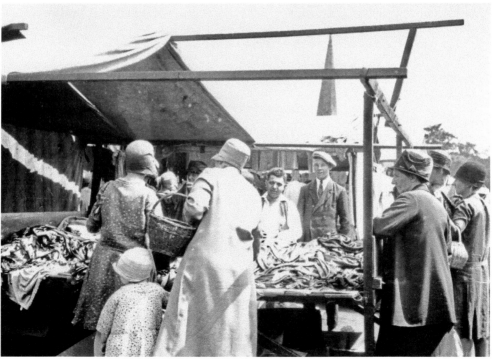

For the second time in the century the town faced the full horrors of war, tragedies devastated many families during the two terrible conflicts and the memorials around the town bear silent witness to the loss. In Holy Trinity Church a plaque remembers three brothers, two of whom were awarded the Victoria Cross (VC). George Nicholas Bradford was a Lieutenant Commander in the Royal Navy and took command of a party that stormed Zeebrugge in 1918 during which his bravery saved the mission but cost him his life and he was awarded a posthumous VC. James Barker Bradford joined the Durham Light Infantry (DLI) and was killed in action in France in 1917. Rowland Boys Bradford also served with the DLI and was awarded the VC in 1916 after he took command of a second battalion when the leader of that unit was killed and went on to complete a successful attack. However, he was killed in 1917 when a stray shell hit the brigade headquarters.

The RAF aerodrome at Middleton St George was the base of more heroes during the Second World War. The airfield was opened in 1941 and in 1943 Canadian Royal Airforce pilots were stationed there and flew bombing raids over Europe. One crew member, Andrew Myranski, was awarded the posthumous VC for his selfless action in trying to help a crew member who was trapped in the gun turret of a Lancaster bomber that had been damaged by enemy fire and was plummeting to the ground. Andrew did not survive but his fellow crew member did thanks to the help he had received.

A pilot from the aerodrome saved many lives in Darlington in January 1945. He was piloting a Lancaster bomber back to the base when an engine caught fire. Soon the wing

From the First World War a drawing of Rowland Bradford from a soldier's notebook. (Reproduced by permission of the Trustees of the former DLI and Durham County Record Office D/DLI 7/920/9(13))

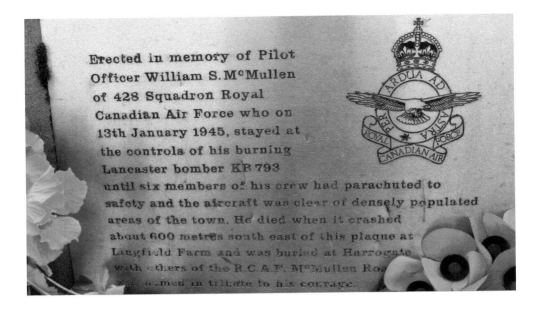

Erected in memory of Pilot
Officer William S. McMullen
of 428 Squadron Royal
Canadian Air Force who on
13th January 1945, stayed at
the controls of his burning
Lancaster bomber KB 793
until six members of his crew had parachuted to
safety and the aircraft was clear of densely populated
areas of the town. He died when it crashed
about 600 metres south east of this plaque at
Langfield Farm and was buried at Harrogate
with others of the R.C.A.F. McMullen Road
was named in tribute to his courage.

Above: A monument to William McMullen on the road named after him.

Left: Close to St Andrew's Church is the war memorial in Haughton. In the background is Butler House, parts of which date to the fifteenth century.

ignited and William Stuart McMullen ordered the crew to parachute out of the plane. Once the crew were safely out he could have then saved himself but by then the burning plane was over the houses of Darlington so he chose to carry on and struggle with the controls and take the plane into the countryside where it crashed in fields close to what is now McMullen Road.

By 1945, near to McMullen Road, plans were already afoot for a new factory development, which one report suggests had its roots back in 1943 at the height of the war. In August two people who managed to arrange a holiday in Blackpool struck up an acquaintance. One was a manager with the firm of Patons and Baldwins and the other was Alderman A. J. Best from Darlington. Alderman Best naturally spoke about his home town and two years later the man from Patons and Baldwins, who by then had been tasked with finding suitable locations for the woollen yarn business to site a new purpose-built factory, was in Darlington renewing his friendship with the councillor.

Patons and Baldwins chose to centre their operations in the town, transferring work from some run-down woollen mills around the country. In September 1945 newspapers reported that the world's largest producer of knitting yarns was to close most of its factories in England and concentrate production in a new, purpose-built facility. Darlington folk read that Patons and Baldwins would be building the new factory on farmer's fields at the edge of town and this would bring up to 3,000 jobs. Most of these would be new jobs, although there were some employees moving from existing factories such as managers, supervisors and staff with specialised skills. Among them were Frank Mattinson, a spinning overseer who moved from Halifax, Hubert Dyson, a dyehouse manager arrived from Melton Mowbray, and from Halifax came Arthur Graydon, his son Tom, and Walter Kehoe, all supervisors. Finding accommodation for these people was difficult – as has been noted there was a shortage of houses in the town. Patons had to buy land and build houses, including in the Broadway and around Estoril Road. These were available to rent by the new arrivals; in 1947 a yarn examining overseer left Wakefield and was in Estoril Road with weekly deductions from his wages to pay the £39 annual rent due.

The story of this major industrial development attracted the attention of the BBC. In August 1949 the radio's Northern Home service invited Ruth Vickery, who had a role in the personnel function, to broadcast her reflections on 'setting up a new community' in Darlington and moving away from Blake's satanic mills. Later when the factory was up and running the BBC were back to broadcast an edition of 'Workers' Playtime' from the factory. This radio programme had started during the Second World War and took entertainers into factories to help boost morale and production. In those years there was danger in announcing the location of the factories, and the show was always billed as coming from 'somewhere in Britain'. For some years after the war it continued to be a popular lunch time variety entertainment and toured the country, setting up equipment at Patons in June 1951.

The media were also invited to a tour of the factory in 1951 and the process of converting fleeces arriving from as far away as Australia and New Zealand into yarn was explained to reporters. The astounding facts about the extensive buildings were revealed. Builders had used 12 million bricks, 15,000 gallons of paint and 10,000 tons of steel and

Left: Constuction workers at the Patons and Baldwins site.

Below: There was a shortage of housing in Darlington. Paton and Baldwins bought land and built houses for essential staff transferred from the mills around the country.

installed 4,351 yards of conveyor belt in the £7 million development. The factory had its own power station, which used 7,000 tons of coal a week and 35,000 gallons of water were needed every day.

In the early years there was no shortage of recruits at the new factory. Many women who had worked during the war were displaced in peacetime. The munitions factory in Aycliffe had brought work; at its height there were 17,000 working at Aycliffe, the vast majority women, filling shells and detonators with explosives. The factory was a dangerous place and despite training in safe working, explosions did happen and in extreme cases there were fatalities. Ruth Vickery had been a labour manager at the Aycliffe facility before moving to Patons. A young lady seeking work at Patons reminded Ruth that she had known her mother who had both hands blown off while working in the Aycliffe factory.

By 1959 a significant problem started to become apparent at the factory: staff recruitment was becoming difficult. As the 1960s progressed the problem of finding staff at Darlington did not ease despite buses bringing people from as far away as Shotton Colliery and Ferryhill. One person living near the factory remembered 'bus after bus leaving at the end of the day'. Staff at the local Employment Exchange knew Patons as the place for anybody looking for work. Some concern about recruitment was expressed in

Women had new opportunities for work during wars. Here are a group working at Whessoe during the Second World War. (Courtesy of Centre for Local Studies, Darlington Library)

the autumn of 1963 with the news that Chrysler Cummins were to start producing diesel engines in the town and employ up to 1,500.

Patons and Baldwins was now operating an international business from its Darlington headquarters. The merger with J. and P. Coates to form J. P. Coates, Patons and Baldwins Ltd increased annual turnover of this worldwide group to over £90 million. This success was not to last; by 1975 the industry was in decline and low-cost imports were causing severe disruption in the UK. The announcement came that around one-third of the 1,750 employed in Darlington would be made redundant. Gradually the Patons operation shrank and the site became little more than a warehouse for yarn arriving from Hungary, Portugal and Brazil. This left large areas of the site empty and tenants were sought to rent space in the abandoned buildings. In November 1976 negotiations had been completed with Carreras Rothmans to lease part of the site. The press release made by this cigarette manufacturer told of 400 jobs being created immediately and when production was running at full capacity a staff of 1,000 would produce 1,000 million cigarettes every month. In 2003 the closure was announced with the firm concentrating production in the UK in Southampton. The site was then developed as Lingfield Point business park.

The historic association of the town with textiles disappeared in 1972 when the Pease mills, which had been sold to Lister & Co. textile manufacturers from Bradford in the 1920s, were finally closed. The mills, which were located between the river and the Crown

This was Paton and Baldwins' grand administration block, built as the headquarters of this multinational yarn business.

Street library and stretched towards Tubwell Row, have gone, demolished by 1984. The remaining Pease business, Pease and Partners, also disappeared. During the Second World war the government had taken control of the coal reserves. The return of peace brought a strategy of nationalisation of the strategic but often run-down sectors of business. Mr A. Whyte, who had been appointed managing director of Pease and Partners as part of the reorganisation in the 1930s, had risen to chairman. He spoke against 'the cramping and unimaginative control of a Department of State' and championed the 'enterprise and initiative of competitive industry'. Nevertheless the collieries were nationalised in 1947 and the iron and steel makers followed. The company had little business left and as the government made compensation payments shareholders were repaid and eventually the one remaining business, the Tees Iron Foundry at Cargo Fleet, was closed and the company was dissolved in 1959.

Heavy engineering also suffered. The Whessoe facility had been expanded through the years, employing up to 1,800 at the Brinkburn Road site in the mid-twentieth century, but fabrication work declined and by 1992 the site was sold. The business moved to offices in Morton Palms concentrating on project management. Demand for Darlington Forge's products declined, as did the number employed, unable to compete with overseas competitors. The business was closed in 1967. The Rolling Mills did not

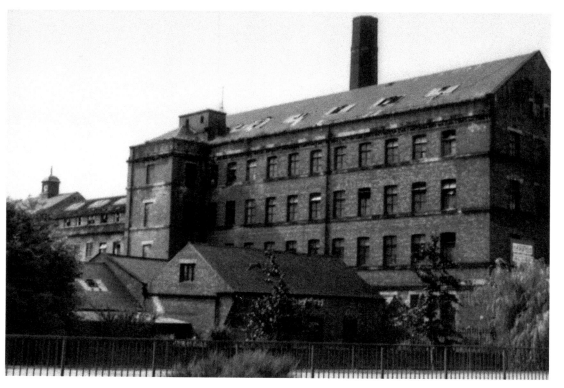

The Pease Mill beside the river in the centre of the town. (Courtesy of Centre for Local Studies, Darlington Library)

survive. Ownership had changed and in 1996 the Darlington and Simpson Rolling Mills was in the hands of British Steel, who could not justify investment needed to modernise the plant and it was closed two years later. Summersons had a similar fate, closing in 1976. In 1937 the Stephenson locomotive works merged with Hawthorn Leslie to become Robert Stephenson and Hawthorns and in 1962 was taken into the English Electric group, although it was still referred to in the town as 'Stivies'. The plant was not to survive. Demand for new engines, particularly from British Rail, was slowing and it was decided to centre production at the firm's plant in Lancashire. The last train rolled out of the works in 1964 and ended a 140-year connection of this business with the town. Like many industrial sites Stephenson's was cleared for housing as was the original Cleveland Bridge facility in Smithfield Road after the business moved to Yarm Road in 1982 and in Brinkburn Road housing has taken over the Whessoe site.

The framework of the giant hammer from the Darlington Forge is now at the entrance to Beamish Museum.

This stonework once stood at the entrance to the Robert Stephenson railway works in Springfield.

The Faverdale Wagon works and the North Road Locomotive works, which had employed over 3,500 between them, were all closed by 1966. The wooden wagons produced at Faverdale were becoming outdated and replaced by those constructed with steel bodies. Despite calls to re-equip the factory to allow these wagons to be built the site was closed. The railways were changing, and the need to modernise had been recognised in the 1950s. Diesel locomotives were cheaper and easier to operate than steam locomotives, which needed fires starting and time was needed to raise steam, while diesels started on the turn of a switch. Although the locomotive works did start to produce this new breed of locomotives, the expansive workshops that built and maintained steam engines were no longer needed. The drastic cutting of much of the railway system contracted the demand for locomotives. Many railway lines and stations were axed after Dr Beeching reported his solution to the mounting losses of British Rail, which in 1962 had reached £104 million. There were many lines in the extensive rail network that were little used and expensive to operate and maintain. Those opposing his proposals for a reduction in the network argued he was not interested in the public service provided by such services and had 'one idea – cut anything that is not paying'. Much of the local railway system suffered. The line to Barnard Castle and beyond closed as did the link to Richmond. Fortunately, parts of the original route of the S&DR are still used including from Darlington across the Skerne Bridge and on towards Shildon, and in the other direction the section that runs past Teesside Airport.

The Beeching cuts were in line with the government's policy, which saw the future of transport in the road system. One disused line, the Merrybent branch, which was built to serve a quarry at Barton, had closed in 1930 but the track bed became part of the motorway that bypassed Darlington in 1965. No longer would Grange Road, Blackwellgate, Prebend Row, Northgate and North Road be part of the A1 road, leaving those visiting the town centre with an easier time crossing from one side to the other. But the roads were taking their toll on the town's role in manufacturing and maintaining locomotives and rolling stock. This, coupled with the decline of the engineering, forced the search for new employment opportunities.

There is one reminder of the North Road Locomotive works: the clock that stood above entrance to the works is still on the site in North Road.

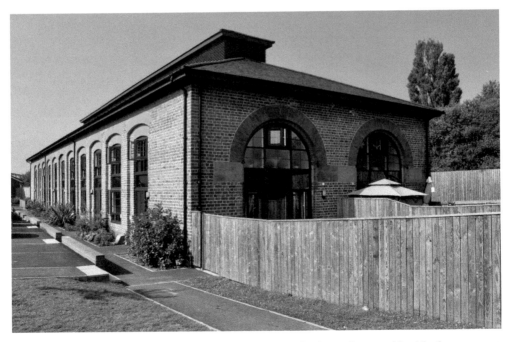

Much of the railway infrastructure, such as turntables and sidings that stood beside the east coast main line, has gone, but this engine shed built for the GNER in the 1840s survived and has been restored and converted into housing.

Just as in the nineteenth century the town's industrial base was transformed. A century later the tide turned again to bring a diverse economic base that brought work in public services, health and education, retail, food and accommodation, financial, distribution and technical services.

The Amazon fulfilment centre providing work in the distribution sector.

Acknowledgements

I must record my gratitude to those who have helped with my research including at Beamish Museum, Durham County Record Office, the Head of Steam – Darlington Railway Museum, Lingfield Point, Darlington Operatic Society and the British Library. A special mention to the Centre for Local Studies in Darlington Library where the extensive and important archive proved invaluable.